Christmas 2004

BASEBALL
IN OKLAHOMA CITY

BASEBALL
IN OKLAHOMA CITY

Bob Burke

ARCADIA

ublished by Arcadia Publishing,
an imprint of Tempus Publishing, Inc.
Charleston SC, Chicago, Portsmouth NH,
San Francisco

Printed in Great Britain.

Library of Congress Catalog Card Number: Applied For.

For all general information contact Arcadia Publishing at:
Telephone 843-853-2070
Fax 843-853-0044
E-Mail sales@arcadiapublishing.com
For customer service and orders:
Toll-Free 1-888-313-2665

Visit us on the internet at http://www.arcadiapublishing.com

For the Burke boys, and all who love America's true pastime—baseball.

CONTENTS

ACKNOWLEDGMENTS

Attempting to chronicle a century of baseball teams and players in Oklahoma City was a huge job, made possible only by the splendid cooperation of many people. The late Pat Petree laid the groundwork for this book by publishing a pictorial history of minor league baseball in the capital city more than 20 years ago.

Bob Hersom, who has covered baseball for *The Daily Oklahoman* for more than two decades, provided much insight and editing, and produced dozens of lists after spending hundreds of hours studying old box scores.

Justin Tinder, the Oklahoma RedHawks Director of Media/Community Relations, and RedHawk General Manager Tim O'Toole willingly opened their files and provided both information and photographs.

Linda Lynn, Melissa Hayer, Mary Phillips, Robin Davison, and Billie Harry assisted in the selection of photographs in the archives of the Oklahoma Publishing Company.

Thanks also to Eric Dabney, Stephanie Ayala, and Robert Burke for research and editorial assistance and to Oklahoma Sports Museum Director Richard Hendricks for photographs.

It was a team effort to preserve the saga of an exciting century of baseball in Oklahoma City.

Bob Burke
2003

INTRODUCTION

Oklahoma City was born grown. Unique among all land settlements in history, the rolling pastures that became Oklahoma City were opened in the Land Run of 1889. Thousands of men, women, and children on foot and on bicycles, horses, oxen, and mules, leapt from the starting line at the sound of cannons and rifles at noon on April 22, 1889. Most of the hearty souls were armed only with a wooden stake with which to mark a parcel of land to call their own. By nightfall, Oklahoma City had 12,000 inhabitants.

Baseball was the sport of choice of Oklahoma Cityans from the beginning. Within days after the prairie was opened to homesteaders, Sunday afternoon baseball games were organized. Soon, teams from Oklahoma City began competing with teams from surrounding towns.

By the fall of 1889, Oklahoma City's first baseball grandstand was built near the location of the present Municipal Building. Fans sat on bleachers made of beer kegs and 2-by-12 boards. The ballpark was thrown up quickly to host a series of games between Oklahoma City and its biggest rival, the team from Oklahoma Territory capital city Guthrie. In 1890, the first permanent grandstand appeared in Stiles Park near Northeast Eighth Street and Harrison Avenue.

The first organized team in Oklahoma City was sponsored by Walter and Harry Jennison in May of 1891. They built a wooden backstop and a new ballpark between Grand Boulevard, and California, Walker and Dewey avenues. The Jennisons' team was called the Pirates—they played their first game on June 19, 1891 against the Purcell Chickasaws. To entice fans to the game, Walter Jennison distributed a flier about town announcing that admission was free and that ladies were especially invited. To allay fears about bad influences at the game, the flier said drinking would not be allowed and betting and prostitution were "absolutely" forbidden on the grounds.

Townball, or town baseball, became an institution in the 1890s in the cities and towns around Oklahoma City. Many businesses sponsored teams that played before sprawling crowds of hundreds dressed in their finest at Sunday afternoon games. Baseball historian Charles Saulsberry called the years 1895 to 1900 "the expansion era" for baseball teams in central Oklahoma. Excursion trains carried fans to surrounding towns, especially Purcell, where a saloon sat in the middle of the South Canadian River to wet the parched throats of fans.

By the beginning of the twentieth century, Oklahoma City fans were aware of the growing stature of baseball as the national pastime. Around hot stoves in winter and under shade trees in summer, talk began about Oklahoma City having its own professional baseball team.

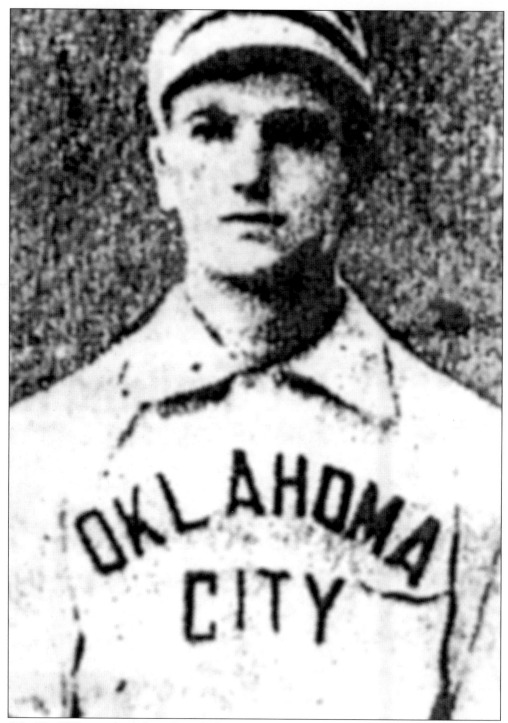

O.L. "Pop" Waner, the father of Baseball Hall of Famers Lloyd and Paul Waner, went from his farm in the Crooked Oak community to the mound for the Oklahoma City town team in 1896. He was a star pitcher for Oklahoma City eight years before the city's first organized professional baseball team would play an entire season in 1904. (Oklahoma Historical Society.)

ONE

The Early Years 1904–1932

Professional baseball came to Oklahoma City in 1902 when clothing merchant and civic leader Seymour C. Heyman, a native of New York City, formed a baseball club and began looking for a league to join. Interest in a professional team was increased by the construction of a popular amusement park, Delmar Garden, the largest American amusement park west of the Mississippi River. The park contained a baseball field, horse racing track, beer gardens, and a roller coaster along the North Canadian River where the present Farmers Market is located. A new streetcar system brought thousands of people to the park, a fact that did not go unnoticed by Heyman and other baseball club investors.

Seymour hired baseball players in 1902 and 1903, but Oklahoma City's first professional baseball team to play in an organized league for a full season took the field in 1904. The Oklahoma City Metropolitans (Mets) played in the Southwestern League and finished third in the four-team league, with a 45-49 record. The Mets were owned by Emmett Rogers and Pat Flaherty and managed by Eugene Barnes, who as a 16-year-old had helped build the original beer keg stands at Oklahoma City's first temporary ballpark. The Mets set up office in a spare room at the Oklahoma Sporting Goods Store on North Robinson Avenue. The Mets' first game was an exhibition contest against the St. Louis Browns, which the Browns won 16-6.

The Mets played in the city's first permanent ballpark structure, Colcord Field, built along the banks of the North Canadian River. Over the years, before it was destroyed by floods in 1923, the ballpark was called Colcord Park, Saratoga Park, Liberty Park, and Western League Park.

In 1905, Barnes bought the Mets, who climbed to a second place finish in the eight-team Class C Western Association, in which they competed through 1908. Ed Hurlbutt of Oklahoma City led the league in batting with a .349 average.

In 1909, with new owner R.E. Moist, Oklahoma City joined Tulsa in a move to the Texas League and changed its nickname to the Indians for three controversy-filled seasons. Oklahoma City and Shreveport were the only league teams outside Texas, and Oklahoma City had to guarantee visiting teams $100, a steep price tag when gate receipts often were less than $400. Texas teams only had to guarantee a visitor $50. There was an out-of-state prejudice, and field fights were common during the games.

In its first Texas League season, the Indians did well, finishing second to Houston. Oklahoma City's Red Downey led the league in batting at .346 and Bill McCormick topped league batters in runs (93) and hits (169).

In the middle of the 1910 season, Moist sold the team, which changed its name back to Mets,

to Abner Davis, president of the Day and Night Bank, for $18,000. There was a major disagreement over the sale and intense litigation was launched, causing the team to go into receivership. Manager George Kelsey was named as the court-appointed receiver.

Davis resumed ownership of the team in 1911 but refused to pay the extra $50 to visiting Texas teams, who responded by withholding Oklahoma City's guarantee when the Mets played in Texas. A doubleheader in Houston was canceled because Davis would not let his team play until he was given his full share of the receipts. The fighting stopped when the franchise was sold to Beaumont, Texas, at the end of the 1911 season.

In 1912, Oklahoma City played in the Oklahoma State League as the Senators and finished seventh of eight teams that included Okmulgee, Tulsa, Holdenville, Muskogee, McAlester, Anadarko, and Guthrie. Financial problems shut down the league by June 2.

There was no team in 1913, but the Oklahoma City Boosters played in the Western Association in 1914. The Boosters won the league championship in a playoff against Muskogee. Glenn Dameron of Oklahoma City won the league batting title with a .344 average.

Oklahoma City's ace hurler, Ray Fagan, had a career year in 1915, when he set three Western Association League records. He was 13-0 with a 1.15 ERA.

Financial problems and World War I contributed to the demise of the Boosters in 1917. Seymour Heyman came to the rescue and found a Western League team in Hutchinson, Kansas, that was looking for a new home. The Kansas Club was owned by John Holland, Sr., who would dominate baseball in Oklahoma City for the next 25 years.

Holland, who moved his club to Oklahoma City, was all business, seldom smiling for photographers. He was an aggressive promoter who knew baseball as a minor league player, manager, and owner. Holland was the field manager for his first two teams, called the Oklahoma City Indians. In 1919, Holland hired Elijah James "Jimmie" Humphries, an itinerant infielder, as team secretary. Humphries was in the front office of Oklahoma City's minor league baseball team for 39 years, one of the longest careers with a single franchise in baseball history. Outfielder George Harper was Holland's dream player in 1921. Harper batted .393, second in the league, and was sold to Cincinnati after the season for $20,000, $2,000 more than the entire Oklahoma City franchise was sold for 11 years earlier.

In 1923, under the leadership of player-manager Fred Luderus, the Indians won the Western League championship with a 102-64 record, one of only three one-hundred-win seasons in a century of minor league baseball in Oklahoma City. The Indians were second to Tulsa in Western League attendance, with 98,000 paid admissions.

The Indians won the 1923 pennant on a muddy, improvised field at the State Fairgrounds where the team moved after a flood destroyed the Western League ballpark on the North Canadian River. Roy "Snake" Allen, one of the Indians' colorful pitchers remembered, "Water was everywhere. It covered the field, the clubhouse, and was as high as the third or fourth row of seats in the grandstand." The temporary field at the Fairgrounds was also flooded the day before the championship game. Allen said, "The diamond was too wet so we went to the outfield, marked off a diamond on the grass and played the game there."

With the memories of the flood and the successful season fresh in fans' minds, Holland began to push for construction of a new park as a civic project. He sold multiple-season passes, or realty stock, for $100 per issue to finance the construction. With volunteer labor, Holland Field at Northwest Fourth Street and Pennsylvania Avenue was completed for the beginning of the 1924 season.

Throughout the 1920s, the Indians had success in the Western League, finishing second in 1926 and winning the division in 1928, but losing to Tulsa in a league playoff.

As early as 1926, Holland applied for admission to the Texas League but was turned down because Texas League officials believed Oklahoma to be the territory governed by the Western League. Holland took his ill-fated application all the way to Baseball Commissioner Kenesaw Mountain Landis.

In its final season in the Western League, Oklahoma City finished second to Tulsa in 1932. Tulsa won the championship by winning four straight playoff games.

The Western League years produced thousands of fans for Oklahoma City minor league baseball. Nationally syndicated columnist James J. Kilpatrick began his love affair with baseball in the 1920s by attending every afternoon game with his father, who was in the lumber business. Kilpatrick said, "Baseball was truly the national pastime. Nothing else touched it. High school football was an autumn passion. But baseball for a boy was the be-all and the end-all."

Year	Team	Finish	W	L	League	Manager	Affiliate
1904	Mets	3 of 4	45	49	Southwestern	Rodgers/Warner/Barnes	
1905	Mets	2 of 8	77	58	Western Assn.	Barnes/Risley	
1906	Mets	5 of 8	70	69	Western Assn.	Chinn	
1907	Mets	5 of 5	86	54	Western Assn.	McFarland	
1908	Mets	3 of 8	81	58	Western Assn.	McConnell	
1909	Indians	2 of 8	79	63	Texas	Kelsey/Andrews	
1910	Mets	7 of 8	63	74	Texas	Andrews/Downey	
1911	Indians	7 of 8	72	77	Texas	Garvin	
1912	Senators	7 of 8	15	33	Oklahoma State	Langley	
1914	Boosters	2 of 6	75	52	Western Assn.	Holliday/Maag	
1915	Senators	2 of 8	76	62	Western Assn.	Maag	
1916	Senators	4 of 8	63	77	Western Assn.	Maag	
1917	Boosters	6 of 8	72	80	Western Assn.	Murray	
1918	Indians	6 of 8	33	37	Western	Holland	
1919	Indians	5 of 8	69	69	Western	Holland	
1920	Indians	3 of 8	82	68	Western	Humphries/Moell/Breen	
1921	Indians	3 of 8	93	75	Western	Breen	
1922	Indians	6 of 8	73	94	Western	Fisher/Egan	
1923	Indians	1 of 8	102	64	Western	Luderus	
1924	Indians	5 of 8	82	86	Western	Luderus	
1925	Indians	3 of 8	88	76	Western	Pettigrew/Luderus	
1926	Indians	2 of 8	100	66	Western	Luderus	
1927	Indians	5 of 8	68	86	Western	Luderus	
1928	Indians	1 of 8	95	67	Western	Gregory	
1929	Indians	2 of 8	88	68	Western	Leifield	
1930	Indians	3 of 8	79	71	Western	Kelly/Brower/Pettigrew	
1931	Indians	5 of 8	70	80	Western	Dixon/Tobin	
1932	Indians	3 of 8	83	67	Western	Luderus	

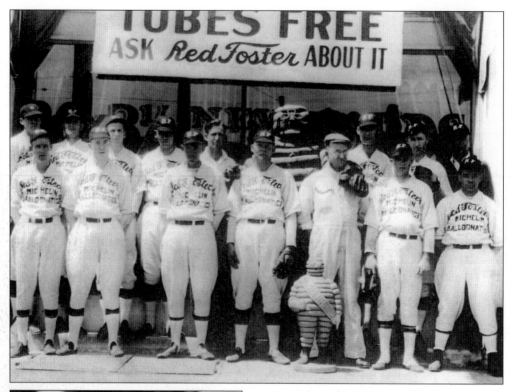

Before the arrival of a professional baseball team in Oklahoma, many businesses sponsored teams that played in commercial leagues, competing against teams from other cities and towns. This is the early team playing for Red Foster Tire Company. Note the Michelin tire figure in front that served as the team mascot. (Oklahoma Historical Society.)

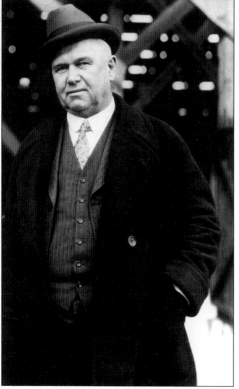

In 1918, in the middle of the season, John Holland Sr. moved his Western League franchise from Hutchison, Kansas, to Oklahoma City, beginning an 18-year run as owner and operator of Oklahoma City's professional baseball club. Holland had the reputation of sitting in an empty park, brooding for hours after his team lost. His vision resulted in the building of a new ballpark for the 1924 season. The park was named Holland Field. (Oklahoma Publishing Company.)

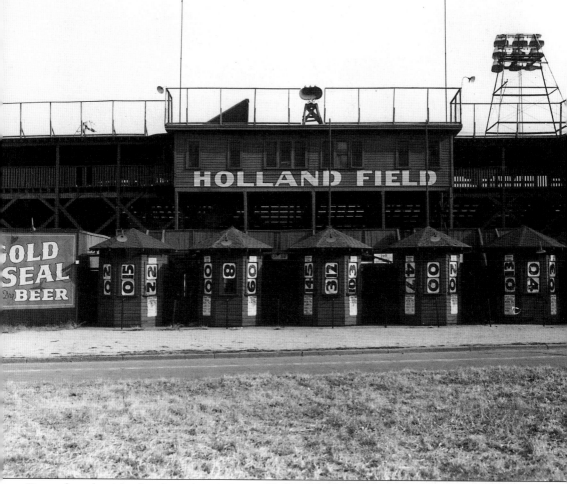

Pictured are the ticket booths at the entrance to Holland Field, the new ballpark built at Northwest Fourth Street and Pennsylvania in Oklahoma City in 1924. The ballpark was later called Texas League Park and was used by area colleges, for statewide sandlot tournaments, and for exhibition games involving both major league teams and Negro leagues teams—especially the Kansas City Monarchs who had many supporters in Oklahoma City. (Oklahoma Publishing Company.)

One of the early sportswriters who promoted baseball in Oklahoma City was Charles W. Saulsberry, a writer for *The Daily Oklahoman* and the *Oklahoma City Times*. Saulsberry teamed with Oklahoma City Indians owner John Holland, Sr., to sponsor a season-ending townball tournament. Holland loaned his ballpark for the tournament which enticed teams from around the state to play in Oklahoma City. In turn, Holland could scout the best players. The highly successful tournament began in 1927. (Oklahoma Publishing Company.)

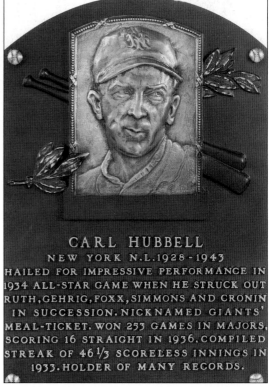

"King Carl" Hubbell, who was raised in Meeker, Oklahoma, had a 17-13 record for the Oklahoma City Indians in 1925. Hubbell was on his way to the majors, where he pitched for 16 years for the New York Giants. Known as the "Meal Ticket," Hubbell dominated hitters in the 1930s. Hubbell was elected to the Baseball Hall of Fame in 1947. He won 20 or more games five consecutive years. His most memorable moment was in the 1934 All-Star game when he struck out five future Hall of Famers in succession—Babe Ruth, Lou Gehrig, Jimmie Foxx, Al Simmons, and Joe Cronin. This is Hubbell's plaque at the Baseball Hall of Fame at Cooperstown, New York. (Baseball Hall of Fame Library.)

CARL HUBBELL

NEW YORK N.L.1928-1943
HAILED FOR IMPRESSIVE PERFORMANCE IN 1934 ALL-STAR GAME WHEN HE STRUCK OUT RUTH, GEHRIG, FOXX, SIMMONS AND CRONIN IN SUCCESSION. NICKNAMED GIANTS' MEAL-TICKET. WON 253 GAMES IN MAJORS, SCORING 16 STRAIGHT IN 1936. COMPILED STREAK OF 46 1/3 SCORELESS INNINGS IN 1933. HOLDER OF MANY RECORDS.

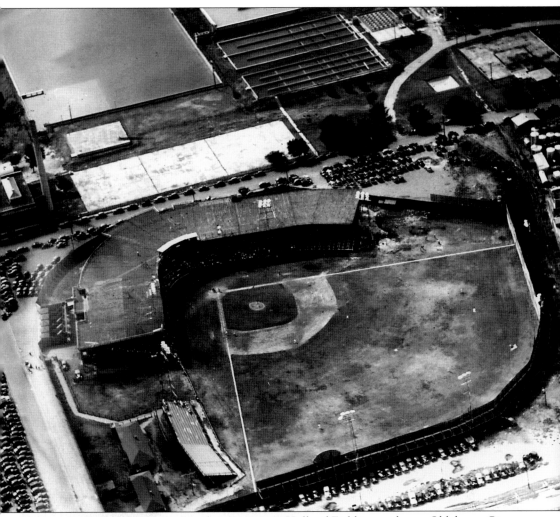

The parking lots are full for a minor league game at Holland Field in northwest Oklahoma City. Fans could either drive to games or ride streetcars that conveniently unloaded at the ballpark gate. Holland Field was built after a flood destroyed Western League Park. Holland sold the idea for public support for a new park by calling it a civic project. He also sold shares in the construction for $100 each, although he avoided securities laws by calling the sales "multiple-season passes." (Oklahoma Publishing Company.)

A frequent visitor to Holland Field for exhibition games was Carl "Sub" Mays of Kingfisher, Oklahoma. His remarkable 15-year career with the Red Sox, Yankees, Reds, and Giants is overshadowed by the fact that Mays' fast-rising submarine fastball caused the only death in a major league baseball game. In 1920, as one of the best pitchers for the Yankees in the days before batters wore batting helmets, Mays cracked the skull of Cleveland's Ray Chapman, who died the next day. Mays' lifetime batting average of .268 makes him one of baseball's best hitting pitchers. (Baseball Hall of Fame Library.)

In the 1920s, Lloyd and Paul Waner, natives of the Oklahoma City suburb of Harrah, became stars in the National League. In this photograph at a Yankee Stadium old-timers game decades later, Paul Dean (left), Lloyd Waner, and Paul Waner recall stories of their childhood in Oklahoma. Dean grew up in Spaulding, Oklahoma. Lloyd Waner was known as "Little Poison." At 5 foot 8 and 142 pounds, he batted over .300 in 12 of his 20 major league seasons. He was elected to the Baseball Hall of Fame in 1967 and was the youngest of the only brother duo ever elected to the Hall of Fame. Paul Waner, known as "Big Poison," led the National League in hitting in 1927, 1934, and 1936. He was the sixth player ever to reach 3,000 hits and holds the major league records of 14 consecutive games with extra-base hits and four doubles in one game. He was inducted into the Hall of Fame in 1965. (Oklahoma Publishing Company.)

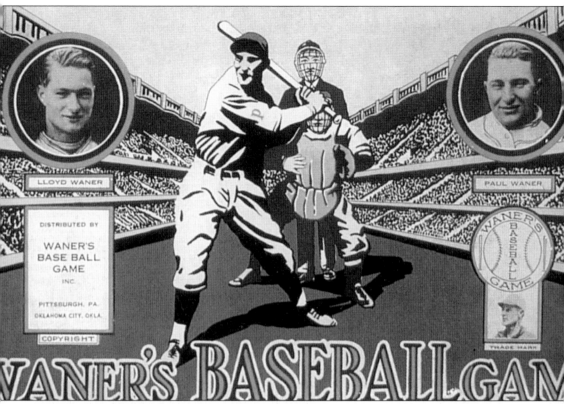

Paul and Lloyd Waner were such major stars for the Pittsburgh Pirates in the 1920s that a baseball board game was named for them. Lloyd Waner holds the major league record for most hits in a rookie season (223), a record that may never be broken. Paul Waner was a hitting coach for several major league clubs after his retirement as a player. He was the National League Most Valuable Player in 1927. The Waners always bragged that the best baseball player in their family was actually their older sister, Alma. The Waners lived on a farm at Harrah, a community adjacent to Oklahoma City. Alma was the only one of the three who could hit a corn cob used in lieu of a baseball over the nearby barn. (Baseball Hall of Fame Library.)

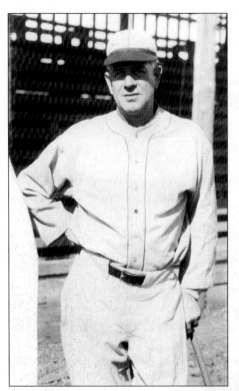

Albert Peter "Lefty" Leifield managed the Oklahoma City Indians to a second place finish in the Western League in 1929. He had an outstanding 12-year run in the major leagues until a sore arm cut short his career at age 28. Liefield won 20 games for the Pirates in 1907 and led Pittsburgh to the pennant two years later. He was involved in a double near-no-hitter in 1906 against the Chicago Cubs. His no-hitter was spoiled in the ninth and Leifield himself spoiled the Cubs' Three Fingers Brown's no-hitter with a single. Lifetime, Leifield won 124 games and pitched three one-hitters. (Oklahoma Publishing Company.)

Willie Wells played for sandlot teams in Oklahoma City before beginning his Negro leagues career with the St. Louis Stars in 1924. Wells, elected to the Baseball Hall of Fame in 1997, was a star in both the Negro leagues and Mexico. One of his great contributions to baseball was the creation of the batting helmet. After he was knocked unconscious in 1936, Wells protected his head by making modifications to a construction worker's helmet. His idea was the forerunner of the modern batting helmet. An Oklahoma City black newspaper called Wells the best shortstop in the Negro leagues in the 1930s. (Baseball Hall of Fame Library.)

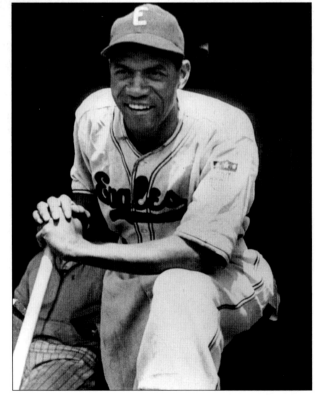

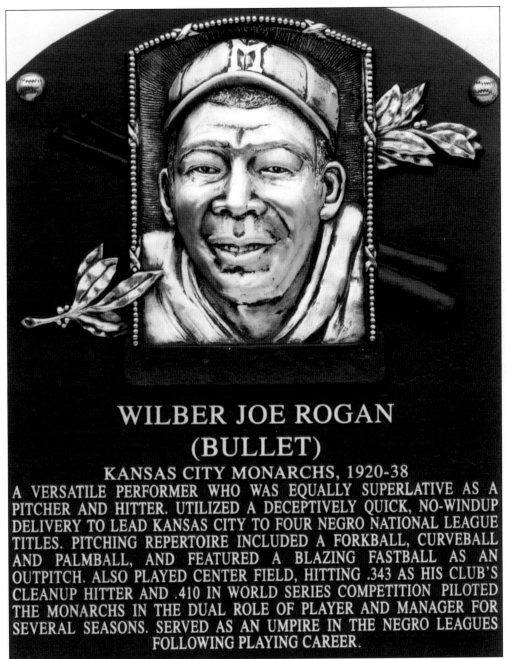

**WILBER JOE ROGAN
(BULLET)**

KANSAS CITY MONARCHS, 1920-38
A VERSATILE PERFORMER WHO WAS EQUALLY SUPERLATIVE AS A
PITCHER AND HITTER. UTILIZED A DECEPTIVELY QUICK, NO-WINDUP
DELIVERY TO LEAD KANSAS CITY TO FOUR NEGRO NATIONAL LEAGUE
TITLES. PITCHING REPERTOIRE INCLUDED A FORKBALL, CURVEBALL
AND PALMBALL, AND FEATURED A BLAZING FASTBALL AS AN
OUTPITCH. ALSO PLAYED CENTER FIELD, HITTING .343 AS HIS CLUB'S
CLEANUP HITTER AND .410 IN WORLD SERIES COMPETITION PILOTED
THE MONARCHS IN THE DUAL ROLE OF PLAYER AND MANAGER FOR
SEVERAL SEASONS. SERVED AS AN UMPIRE IN THE NEGRO LEAGUES
FOLLOWING PLAYING CAREER.

Wilber "Bullet Joe" Rogan was elected to the Baseball Hall of Fame in 1998. He was born in Oklahoma City in 1889 only three months after the famous of Run of '89 opened central Oklahoma to settlement. In 1920, at age 31, Rogan began an illustrious career with the Kansas City Monarchs, the premier team of the Negro Leagues. Some writers who saw both Rogan and Satchel Paige pitch say Rogan was more overpowering. Babe Herman, the legendary Dodger star, batted against Rogan when the pitcher was over the age of 40. Herman said Rogan was the best "colored pitcher" he ever hit against, including Paige, who replaced Rogan as the ace of the Monarchs pitching staff.(Baseball Hall of Fame Library.)

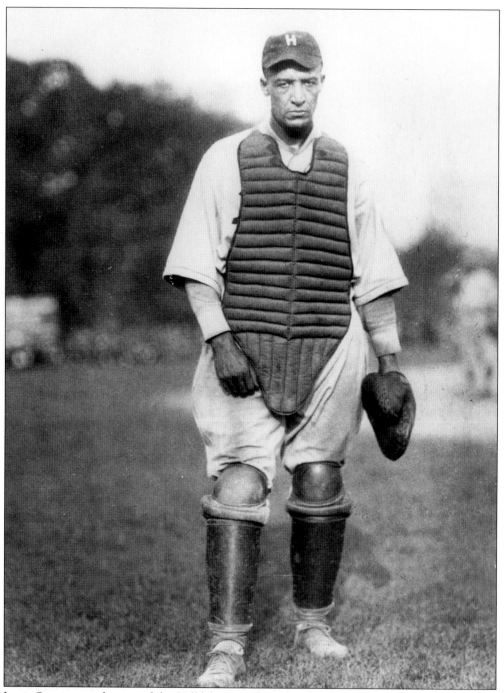

Louis Santop was the star of the Hilldale team that played in the first Negro World Series in 1924. As a catcher and outfielder, he hit tape-measure home runs even in the dead-ball era. A big man, 6 foot 4 and 240 pounds, Santop played for the Oklahoma Monarchs of the Negro leagues in 1909 and was one of black baseball's early superstars. He hit .470 for the New York Lincoln Giants in 1911. (Baseball Hall of Fame Library.)

TWO

The Texas League
1933–1957

The Indians made less than a major impression on other teams in the prestigious Texas League, finishing dead last in their first two seasons, 1933 and 1934. Sixty thousand fans saw home games at Holland Field in 1933, a respectable number for Oklahoma, which was gripped by dust storms and the Great Depression.

The Indians lost 15 straight games on their first road trip in the Texas League, slipped into the cellar, and remained there for most of the summer. They finished 32 1/2 games behind first place Houston, despite decent pitching performances by Vern Kennedy and Al Benton. Kennedy led the league in games pitched with 48.

In the Indians' front office, Holland and Jimmie Humphries, were building for the future. In 1935, under manager Bert Niehoff, the team went from last place to first place, won the Texas League pennant, and whipped Atlanta of the Southern Association in the Dixie Series. Ironically, the Indians had no working agreement with any major league club and built their team by dealing for players on the open market. Including the playoffs, the Indians won 103 games in 1935. More than 121,000 fans showed up for home games, twice the number of the year before.

John Holland, Sr., died in 1936, leaving control of the team to his son, John Holland, Jr. At 27, the younger Holland was the youngest top executive in professional baseball. He had worked in the Oklahoma City baseball operation since his teenage years.

In 1937, the Indians finished first in the Texas League standings with 101 wins. Pitcher Ash Hillin set a league record with 31 wins.

After struggling to keep quality players in the lineup, Humphries secured a working agreement with the Cleveland Indians in 1941. Future major leaguers Jim Hegan, Thurman Tucker, Dixie Howell, Ed Lopat, and Bill Voiselle were sent to Oklahoma City for development. Hall of Famer Rogers Hornsby was the Indians' field manager in 1940 and 1941, until the team ran out of money to pay him.

The Texas League suspended play from 1943 to 1945 because of World War II. When the league voted to resume play in 1946 as a Class AA league, oilman Harold O. Pope became the sole owner of the Indians, buying out partner Charles R. Virtue. The two had bought the team at the end of the 1942 season from the John Holland, Sr., estate.

With World War II over, scores of players returned to the Texas League. Oklahoma City did not have a working agreement with a major league club, making it difficult to field a great team. However, fans appreciated the return of baseball to the city. Even though the Indians finished last, they drew more than 120,000 fans, triple the number of fans who attended games in 1942.

One of the stars of the 1946 Indians was Dale Mitchell, a recent University of Oklahoma graduate, who led the league in batting with a .337 average.

In 1947, Al "Flip" Rosen nearly rewrote the Texas League record book, leading the league in batting, hits, doubles, and RBIs. He was also named the league's Most Valuable Player.

In 1948, Pope sold the Indians to Bill Veeck and Rudie Schaeffer of the Cleveland Indians. Jimmie Humphries became the team president. The following year, the new owners gave the Indians a new look with new uniforms and 700 more seats for Holland Field, now called Texas League Park. The Indians finished third and Herb Conyers won the league batting title and was the Most Valuable Player. Attendance was phenomenal—more than 8,000 on opening day and 287,858 for the season.

Manager Joe Vosmik's team in 1950 finished sixth but would have been better had not the parent Cleveland Indians called up Jim Lemon, a tall, heavy-hitting outfielder, in the middle of the season. Lemon was hitting home runs at a pace to break the all-time club record. After Lemon left, the Indians slipped from pennant contention, and attendance dropped more than 100,000 over the previous year.

Oklahoma City's affiliation with Cleveland ended in 1951 when Veeck bought controlling interest in the St. Louis Browns. Because the Browns owned and operated San Antonio of the Texas League, a conflict of interest arose. Veeck sold his interest in the Oklahoma City franchise to Humphries, who brought in Tommy Tatum to manage the Indians in 1951.

Humphries also signed Oklahoma Cityan Frank Kellert, fresh from a successful career at Oklahoma A & M College in Stillwater. Kellert led the league in doubles with 42. Humphries purchased the contract of outfielder Bob Nieman from Tulsa. Nieman won the league batting championship, hitting at a .324 clip. Attendance slipped to 109,181 and the Indians failed to make the playoffs. However, Humphries sold Nieman and pitcher Duke Markell to the St. Louis Browns, giving him enough money to keep the team running for another season.

The Indians reached the playoffs in 1952 and 1953, when Joe Frazier led the Texas League in batting, runs scored, total bases, and doubles. Outfielder Russ Burns led in RBIs.

Because of sagging attendance, Humphries struggled to keep great players. Economics forced him sell his best players to major league clubs, just to keep enough money on hand to make payroll. In 1954, he negotiated a $300,000 loan from First National Bank and Trust Company to build a new ballpark at the State Fairgrounds, to rekindle fan interest and raise capital by selling Texas League Park. However, city fathers relegated the plan to the back burner. The architect's plans were similar to the park that later would be built as All Sports Stadium.

With dreams of a new ballpark gone, and plagued by deep financial problems, Humphries sold the 10 acres upon which Texas League Park was located. He had done all he could to make the franchise work. But with no local ownership interest, the Oklahoma City Texas League franchise was terminated after the 1957 season.

Year	Team	Finish	W	L	League	Manager	Affiliate
1933	Indians	8 of 8	62	90	Texas	Luderus/Harvel	
1934	Indians	8 of 8	59	93	Texas	Harvel	
1935	Indians	1 of 8	95	66	Texas	Niehoff	
1936	Indians	4 of 8	79	75	Texas	Niehoff	
1937	Indians	1 of 8	101	58	Texas	Keesey	
1938	Indians	3 of 8	89	70	Texas	Keesey/Fitzpatrick	
1939	Indians	7 of 8	59	102	Texas	Hass/Moore	
1940	Indians	4 of 8	82	78	Texas	Keesey/Hornsby	
1941	Indians	6 of 8	69	85	Texas	Hornsby/Peel	Cleveland
1942	Indians	7 of 8	69	85	Texas	Peel/Payton Kroner/Touchstone	New York
1946	Indians	8 of 8	54	98	Texas	Schalk	Cleveland
1947	Indians	6 of 8	71	83	Texas	Schalk/Ankenman	Cleveland
1948	Indians	6 of 8	70	84	Texas	Ankenman	Cleveland
1949	Indians	3 of 8	81	72	Texas	Vosmik	Cleveland
1950	Indians	6 of 8	72	79	Texas	Vosmik/Gowdy/Reis	Cleveland
1951	Indians	6 of 8	75	86	Texas	Tatum	
1952	Indians	4 of 8	82	79	Texas	Tatum	
1953	Indians	4 of 8	80	74	Texas	Tatum	
1954	Indians	3 of 8	87	74	Texas	Tatum	
1955	Indians	7 of 8	70	90	Texas	Tatum/Laskowski	
1956	Indians	8 of 8	48	106	Texas	Laskowski/Cash/Beeler	Boston
1957	Indians	7 of 8	66	86	Texas	Robinson	Boston

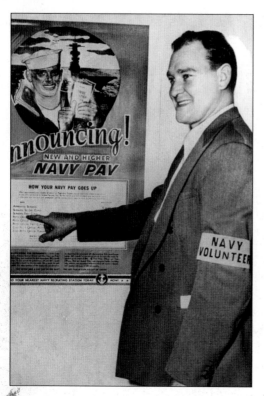

Al Benton, a native of Noble, Oklahoma, got his break in baseball when Indians owner John Holland, Sr., offered to pay Benton's travel expenses to training camp. Benton showed up in tennis shoes, overalls, and a faded red sweater, prompting Holland to advance him $10 to buy baseball shoes. "Fireball Al" was a star pitcher for Oklahoma City from 1932 until 1934, when Connie Mack spotted him. In this photograph, Benton points to a Navy poster after he volunteered for service in World War II. He spent 11 seasons in the major leagues, most of them with Detroit. He pitched the final five innings for the American League in the 1942 All-Star game and got Mel Ott, Enos Slaughter, and Ernie Lombardi to hit fly balls in the bottom of the ninth, just two minutes before the game would be called because of a 10:00 p.m. wartime blackout. Benton was the only man in major league history to pitch to both Babe Ruth and Mickey Mantle. (Oklahoma Publishing Company.)

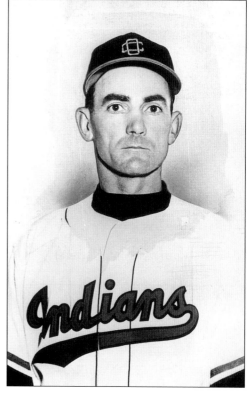

Vern Kennedy was the Indians' best pitcher in 1933, the team's first year in the Texas League. He pitched in 48 games, tops in the league, and finished with a 15-8 record. After his stint with Oklahoma City, Kennedy pitched in 344 major league games over 12 seasons with the Reds, White Sox, Tigers, Browns, Phillies, and Indians. He tossed a no-hitter against Cleveland on August 31, 1935. The next year, he was 21-9 but led the American League with 144 walks. He was named to the All-Star team in 1936 and 1938. He pitched for the Oklahoma City Indians twice, 20 years apart. After his major league career, he rejoined Oklahoma City for the 1953 season. He was 4-4 in 44 games. (Oklahoma Publishing Company.)

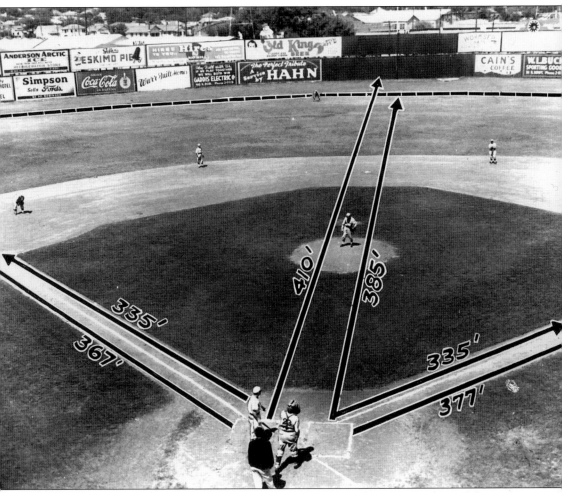

335'

367'

410'

385'

335'

377'

Holland Field, or Texas League Park, seen as it appeared in May of 1939. Note the proliferation of outfield wall signs. John Holland, Jr., and Jimmie Humphries used innovative marketing ideas to sell space in programs and on ballpark walls to raise cash for operations. Without a working agreement with a major league club, it was important to raise money from local advertising and ticket sales. Texas League Park was kept in prime condition by the grounds crew, which often included teenagers working for very little money—they were paid in passes to ballgames. (Oklahoma Publishing Company.)

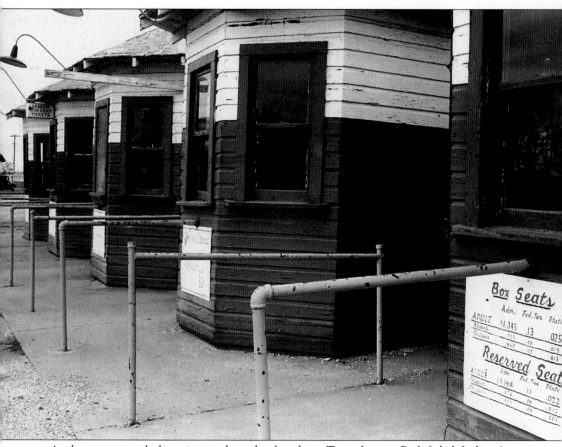

As the years passed, the paint on the ticket booths at Texas League Park faded. Indians' owners were plagued with financial problems. The Great Depression and World War II were followed by the advent of sports on television and a sputtering Oklahoma economy. A fresh coat of paint and 700 seats were added to the ballpark when Bill Veeck purchased the franchise in 1948. (Oklahoma Publishing Company.)

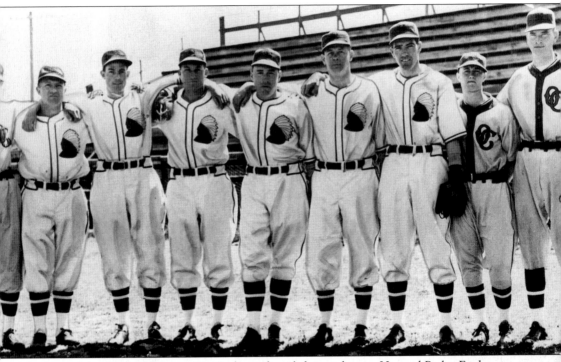

Members of the 1936 Oklahoma City Indians, from left to right, are Howard Parks, Fred Stiely, Oadis Swigart, Eddie Marleau, Jack Brillheart, Charles "Dutch" Schesler, Herschell "Buzz" Arnett, Dick Stone, and Jack Van Orsdol. (Oklahoma Publishing Company.)

The 1939 field manager for the Indians was Wilcy Moore of Hollis, Oklahoma, who posted a seventh place finish and a 59–102 record. He was one of the first pitchers in the majors to gain notoriety as a reliever. As a 30-year-old rookie, he was one of the best pitchers on the 1927 Yankees, the year Babe Ruth hit 60 home runs on a club that many baseball fans consider the best team in history. Moore was 19–7 and led the American League with 13 wins in relief and with a 2.28 ERA. He saved the first game and won the fourth and final game of the 1927 World Series. He also was the winner of the Yankees final win over the Cubs in the 1932 World Series. (Oklahoma Publishing Company.)

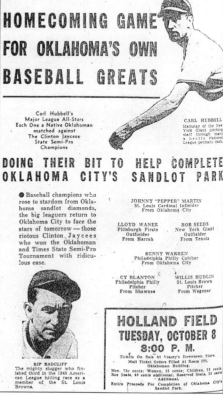

This is a newspaper advertisement for a 1940 homecoming game for Oklahoma sandlot stars who had gone on the major leagues. Among the big leaguers who played in the game were Lloyd Waner, Pepper Martin, Cy Blanton, Willis Hudlin, Benny Warren, Carl Hubbell, Bob Seeds, and Rip Radcliff. Proceeds from the exhibition game benefited a drive to build a new sandlot baseball park in Oklahoma City. (Oklahoma Publishing Company.)

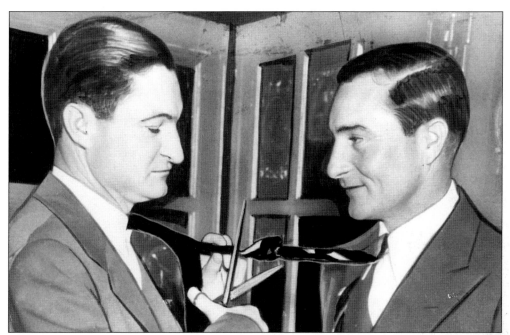

Oklahoma County's Hall of Famers, Lloyd Waner (left) and his brother, Paul, use scissors to cut the knot, symbolizing their parting in 1941 after playing 14 years together for the Pittsburgh Pirates. Lloyd stayed with the Pirates after Paul was traded to the Brooklyn Dodgers. (Oklahoma Publishing Company.)

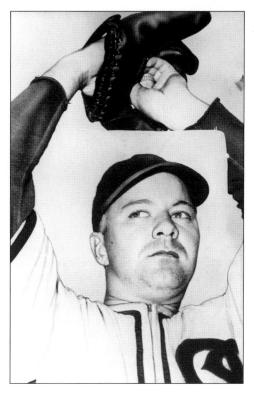

Eddie Lopat was among a group of future major leagues sent for development to Oklahoma City by the Cleveland Indians in the early 1940s. Lopat became one of the best pitchers in the American League. He frustrated batters with slow-breaking pitches and became known as the "Junk Man." After four seasons with the White Sox, he was traded to the Yankees in 1948 where he pitched in the rotation between Allie Reynolds and Vic Raschi. He roomed with Reynolds on road trips. Lopat averaged 16 wins a season from 1949 to 1953, when New York won five consecutive world championships. He won a career high 21 games in 1951 and led the American League with a 2.42 ERA. After retirement as an active player, he managed the Kansas City Athletics in 1963 and 1964. (Oklahoma Publishing Company.)

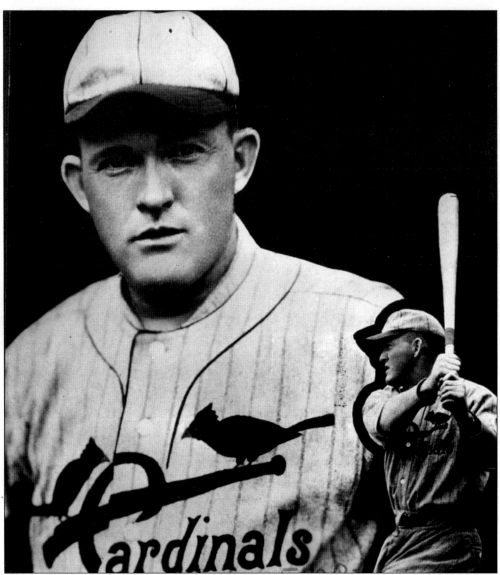

Rogers Hornsby, the great "Rajah," was the $1,000-a-month field manager for the Oklahoma City Indians in 1940 and until the team ran out of money in 1941. Hornsby was baseball's best right-handed hitter of all time. He stood far back in the batter's box and strode into the pitch with a perfectly level swing. He was a power hitter, leading the league four times in doubles, once in triples, and twice in home runs. His 289 home runs are the most for any second baseman ever. Hornsby is in the top 15 hitters in history in a number of categories. His lifetime batting average of .358 is second only to Ty Cobb. He won the National League Triple Crown in 1922 and 1925, the only player in the Senior Circuit to ever win that honor. He was elected to the Hall of Fame in 1942, the year after he managed the Indians, and holds the distinction of appearing as a player or manager in more games than anyone else in baseball history. (He played in 2,259 games and was manager for another 1,530 games.) Hornsby's older brother, Pep, and youngest son, Bill, also played baseball in Oklahoma City. Pep was a Texas League pitcher from 1906 to 1915 and Bill played in the infield for the Indians for part of the 1951 season. (Oklahoma Publishing Company.)

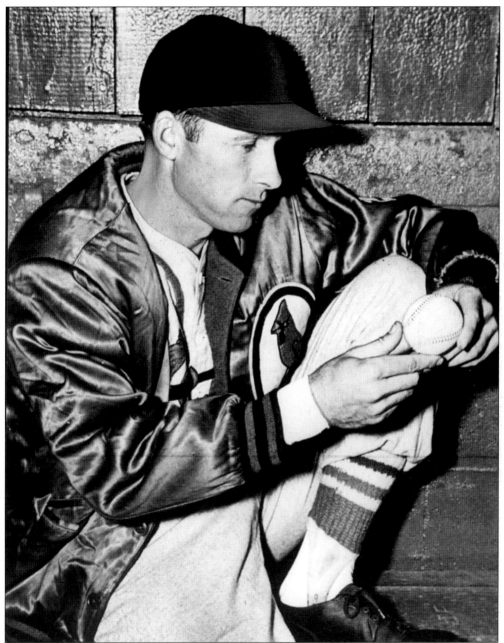

Harry "The Cat" Brecheen appeared at many exhibition games at Texas League Park. A native of Broken Bow, Oklahoma, Brecheen learned how to throw a screwball from Cy Blanton during barnstorming tours promoted by Blanton and Lloyd and Paul Waner. Brecheen was a star pitcher for the St. Louis Cardinals for a dozen years and later developed great pitchers like Jim Palmer as pitching coach for the Baltimore Orioloes. Brecheen won 14 or more games in six straight seasons in the 1940s. In 1946, he became the first left-hander to win three games in a World Series as the Cardinals defeated the Red Sox. His nickname came from a sportswriter who thought he was "as quick as a cat" in fielding his position. Brecheen's ERA of 0.83 in the World Series is one of the best in baseball history. (Oklahoma Publishing Company.)

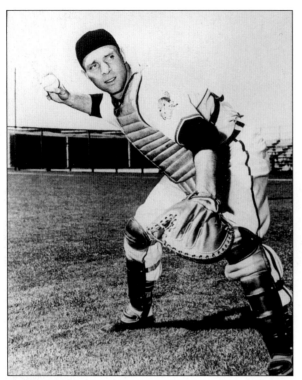

Another Cleveland Indian who learned his baseball fundamentals playing for Oklahoma City was catcher Jim Hegan, who started behind the plate for the Indians in 1941 until called up to the majors. In a 17-year career with Cleveland, Detroit, Philadelphia, New York, and Chicago, Hegan was known for his excellent defense. His lifetime batting average was low, .228, but he hit 14 home runs in both 1948 and 1950 and was among the favorite players of Cleveland fans. Many observers give Hegan a lot of the credit for developing Cleveland's superb pitching staff in the 1940s and 1950s. He was quick from behind the plate on pop-ups and his strong arm was respected by base runners. (Oklahoma Publishing Company.)

Dale Mitchell, of Colony, Oklahoma, led the Texas League in batting with a .337 average in 1946. Mitchell came to Oklahoma City from the University of Oklahoma where he established the still-standing batting mark of .467. At the end of the 1946 season, Mitchell was called up to the parent Indians and batted .432 in the final 11 games. He played 11 seasons in the majors with Cleveland and Brooklyn. He was an All-Star in 1949, 1951 and 1952. He played in three World Series, including 1956 when he was at the plate and took a called third strike to complete Don Larsen's perfect World Series game. Until his death in 1987, Mitchell maintained that Larsen's last pitch was a ball. It was Mitchell's last at-bat in the big leagues. He was one of the toughest batters to strike out and was named to Casey Stengel's all-opponent team. The baseball field on the University of Oklahoma campus is named for Mitchell. (Oklahoma Publishing Company.)

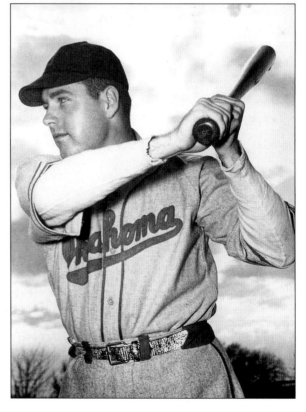

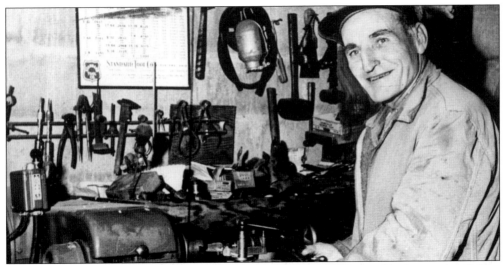

John Leonard Roosevelt "Pepper" Martin grew up in Oklahoma City and broke into baseball at age 18 playing for sandlot teams. As a teenager, he sold soda pop at the Western League ballpark and drove a ballyhoo wagon advertising Oklahoma City Indian games. Part of the Cardinals' Gashouse Gang, Martin played baseball with reckless abandon and passion. His bellyflop slides were his trademark—he led the National League in stolen bases and run scores three times. Possibly the greatest domination of a World Series by a single player came when Martin was 12 for 18 in the first five games of the 1931 World Series. After the Series, Martin was so popular that the nation's newspapers began a weekly installment series called "The Life of Pepper of Martin." This photograph shows Martin working in his shop at his home in the San Bois Mountains of southeast Oklahoma. (Oklahoma Publishing Company.)

Curt Gowdy (front center) talks with Oklahoma City high school athletes in 1947, the year he became the radio voice of the Oklahoma City Indians. Gowdy was discovered when Ken Brown, the general manager of KOMA Radio in Oklahoma City, heard him doing play-by-play of a high school game while driving through Wyoming one night. Gowdy moved to Oklahoma City and broadcast University of Oklahoma football and basketball and Oklahoma A & M basketball. He got his start in baseball announcing when, for $75 a week, he broadcast Oklahoma City Indian games in 1947. Gowdy described the Indians' play-by-play stint as the biggest break in his career. "Someone once asked me if I had to take a young broadcaster and mold him from scratch, what would I do," Gowdy said. "I told him I would make him handle minor league baseball. It's the greatest teacher there is." Gowdy was inducted into the writers and broadcasters' wing of the Baseball Hall of Fame in 1984. (Oklahoma Publishing Company.)

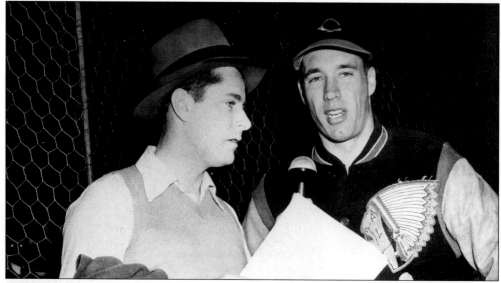

Oklahoma City broadcaster Curt Gowdy (left) interviews Cleveland Indian fireballer Bob Feller before a 1947 exhibition game in Oklahoma City. Gowdy was the voice of the Oklahoma City Indians in 1947 and 1948. He became one of America's most respected sportscasters. He teamed up with Mel Allen on Yankee broadcasts in 1949 and was the voice of the Boston Red Sox from 1951 to 1956. His greatest popularity came as the play-by-play announcer for NBC's Game of the Week from 1966 to 1975. He called the action on every World Series and All-Star game during that decade. During his broadcasting stint in Oklahoma City, Gowdy married a local girl and has maintained his close relationship with the city for a half century. (Oklahoma Publishing Company.)

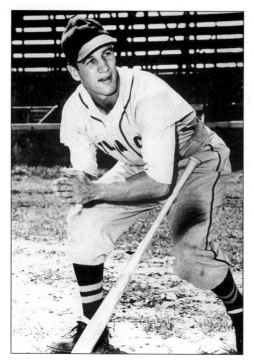

Many Oklahoma City Indian fans name Al "Flip" Rosen as their favorite player of the 1940s. In 1947, he had a career year, leading the Texas League in batting, hits, doubles, total bases, extra-base hits, and RBIs. For his one-man offensive show, he was the League's Most Valuable Player. Rosen pleased fans with his superstitious marking of an "X" in the dirt on the opposite side of home plate when he batted. In the majors, he led the American League with 37 home runs as a rookie in 1950. In 1953, he led the league in homers and RBIs but lost the batting title to Mickey Vernon on the final day of the season. He was a unanimous choice of American League Most Valuable Player in 1953. Rosen hit back-to-back home runs in the 1954 All-Star game. After retirement as a player, he was president of the New York Yankees, the Houston Astros, and the San Francisco Giants. (Oklahoma Publishing Company.)

34

Maybe the most imaginative promoter in baseball history was Bill Veeck (right) who bought the Oklahoma City Indians in 1948. Here he receives an award from Oklahoma City city manager William Gill Jr., at a 1948 All-Sports banquet at the Biltmore Hotel. The Indians, under Veeck's guidance, set annual attendance records during his three-year ownership. In 1949, attendance jumped to 287,858—40,000 more than the previous year. After his ownership in Oklahoma City, Veeck owned the St. Louis Browns, Chicago White Sox, and Cleveland Indians. He was a sound baseball executive who shall forever be remembered for hiring a midget to bat for his White Sox in 1952 as a publicity stunt. (Oklahoma Publishing Company.)

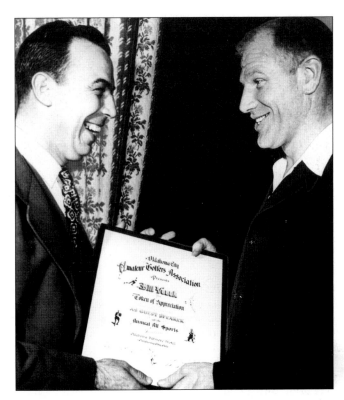

Ray Boone was the Oklahoma City Indians shortstop until called up in 1948 to replace Cleveland shortstop-manager Lou Boudreau. Oklahoma City fans were disappointed because Boone was hitting .355 in the Texas League. He began his baseball career as a catcher but switched to shortstop because of committing so many errors behind the plate. Boone led the American League in RBIs in 1955 playing for the Tigers. His Son, Bob, became an outstanding catcher who played in more than 2,000 games behind the plate. His grandson, Brett, is a star for the Seattle Mariners. (Oklahoma Publishing Company.)

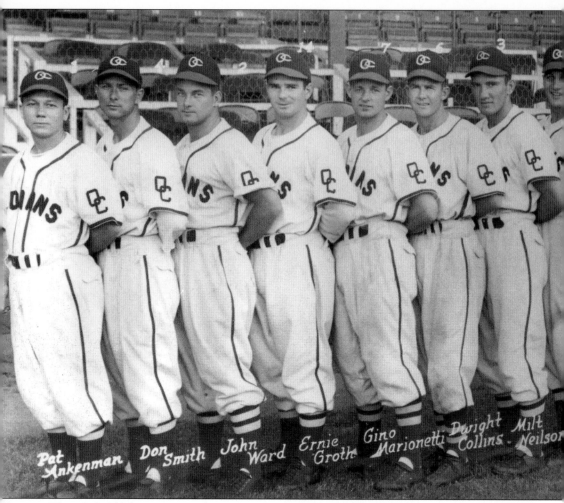

The 1947 Oklahoma City Indians, from left to right, are Manager Pat Ankeman, Don Smith,
John Ward, Ernie Groth, Gino Marionetti, Milt Neilson, Glenn Blackwood, Calvin "Preacher"

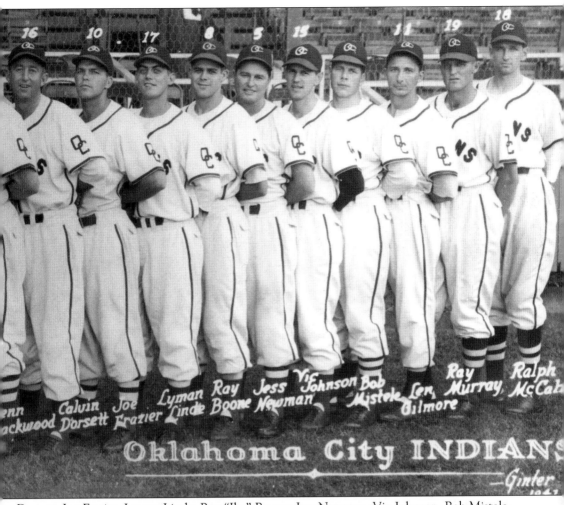

Dorsett, Joe Frazier, Lyman Linde, Ray "Ike" Boone, Jess Newman, Vic Johnson, Bob Mistele, Len Gilmore, Ray Murray, and Ralph McCabe. (Oklahoma Historical Society.)

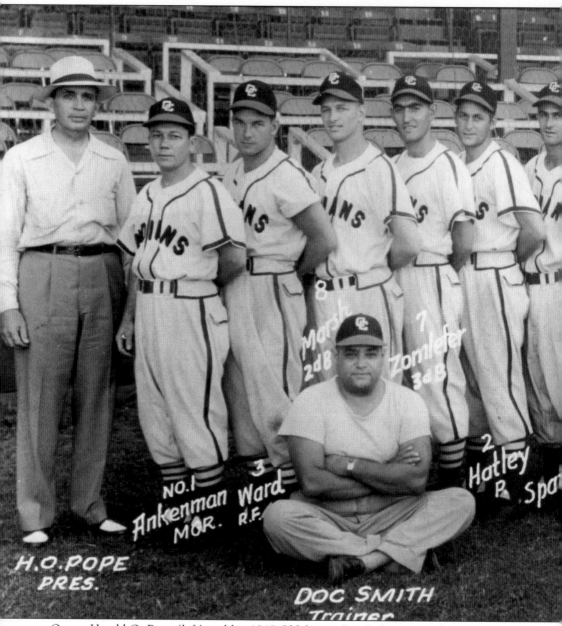

Owner Harold O. Pope (left) and his 1948 Oklahoma City Indians. Standing next to Pope is

7 6 19 17 15 21 14 9 16 13
rnandez Nielsen Westerkamp Johnson Holland Flannigan Deem Boone Dorsett Garc
1stB L.F. C. P. P. P. C. SS P. P.

klahoma City Indians

manager Pat Ankenman. Trainer Doc Smith is seated in front of the players. (Oklahoma Historical Society.)

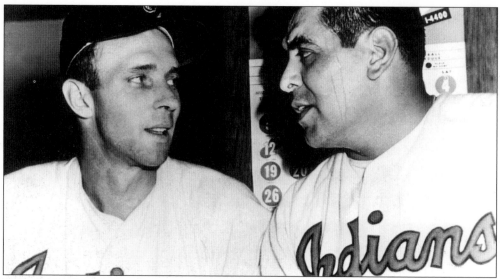

Mike Garcia (right) was the best pitcher for the Oklahoma City Indians in 1948. He was 19-16 with a 3.90 ERA. "Big Bear" Garcia was 14-15 in his rookie season for parent Cleveland in 1949 and won 20 games in 1951 and 1952. His 1954 ERA of 2.64 was the best in the American League. A bad back limited his major league career to 14 seasons. Garcia was part of the great Indian pitching staff that included Bob Feller, Bob Lemon, and Early Wynn. In this photograph, two former Oklahoma City Indians, Garcia and catcher Jim Hegan, congratulate each other after a September 9, 1954 win over the Red Sox. (Oklahoma Publishing Company.)

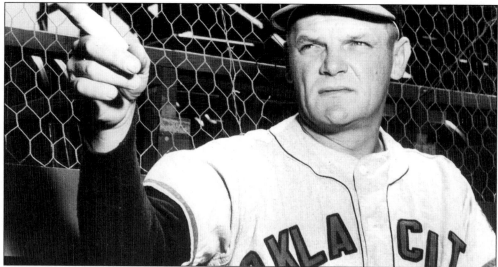

Owner Bill Veeck brought former major league player Joe Vosmik to Oklahoma City as field manager for the 1949 and 1950 seasons. Vosmik also occasionally pinch hit with a .350 average. He batted .307 lifetime in 13 major league seasons for St. Louis, Boston, Cleveland, Brooklyn, and Washington. He made the American League All-Star squad in 1935 when he topped the junior circuit with 216 hits, 47 doubles, and 20 triples. He lost the batting crown to Buddy Myer by a single percentage point. The year before he arrived in Oklahoma City, Vosmik led the American Leauge with 201 hits. He hit .300 or better in six of his major league seasons. (Oklahoma Publishing Company.)

In 1949, Bob Murphy, a graduate of the University of Tulsa, became the radio play-by-play announcer for the Oklahoma City Indians. He moved on to the major leagues in 1953 and broadcast games for the Red Sox and Orioles before becoming the first voice of the New York Mets in 1962. He was the Ford C. Frick Award winner in 1994 at the Baseball Hall of Fame. His late sportswriter brother, Jack, was the namesake for San Diego's Jack Murphy Stadium. (Baseball Hall of Fame Library.)

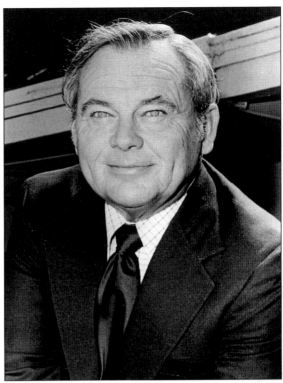

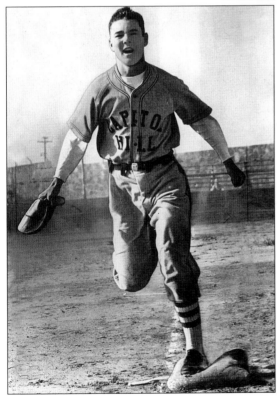

All All-State third baseman at Capitol Hill High School in Oklahoma City in 1949, Tom "Snake" Sturdivant won 16 games for the Yankees just seven years later in 1956. While a Yankee, he roomed with Whitey Ford. In 1959, he was traded to the Athletics and played for five different teams the remainder of his career. He pitched in six World Series games with a 4.34 ERA and a 1-0 record. His best World Series effort was a complete game win over the Dodgers in 1956. He also pitched in the famous 23-inning game between the Giants and Mets in 1964. Sturdivant was on the Oklahoma City roster briefly in 1964. (Oklahoma Publishing Company.)

Two future major leaguers are seen playing YMCA basketball in Oklahoma City in 1947. Calvin Coolidge Julius Caesar Tuskahoma "Cal" McLish, left, a pitcher at Central High School, pitched a scoreless final two innings of the 1959 All-Star game to preserve the win for fellow Oklahoman and American League hurler Jerry Walker. McLish went directly from American Legion baseball to the Dodgers as age 18 in 1944. He pitched 15 seasons for several major league clubs. In 1959, he set a major league record with 16 consecutive road wins, a record he shared for nearly 40 years. The other youngster in the photograph is Bobby Morgan, a graduate of Oklahoma City's Classen High School. In 1949, Morgan was the Most Valuable Player of the International League before being called up to the Dodgers and famous teams called the "Boys of Summer." Morgan hit .233 in 671 games over eight major league seasons. (Oklahoma Publishing Company.)

Before being called up to the parent Cleveland Indians, Joe Frazier played for Oklahoma City in 1947. He returned to the local Indians in 1952 and hit a league-leading 55 doubles. The following year, Frazier led the Texas League in batting, runs scored, total bases, and doubles, and was named the league's Most Valuable Player. He managed the New York Mets in 1976 and 1977. His 1976 Mets finished third in the National League. (Oklahoma Publishing Company.)

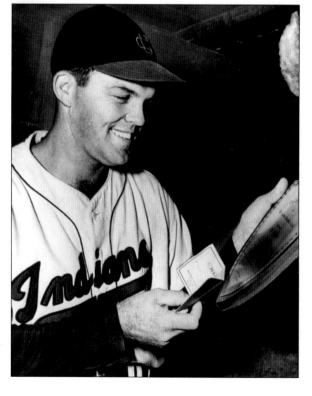

Oklahoma City native Hank Thompson was the first black player for both the New York Giants and the St. Louis Browns. In 1949, he made history when he batted against Don Newcombe—the first time in major league history that a black pitcher faced a black batter. Thompson played six seasons in the Negro Leagues for the Kansas City Monarchs before Bill Veeck discovered him and signed him to play for the Browns. Thompson had his best big league season in 1953 when he hit .302 with 24 home runs for the Giants. He hit .343 lifetime in the Negro Leagues and .267 in the majors. (Oklahoma Publishing Company.)

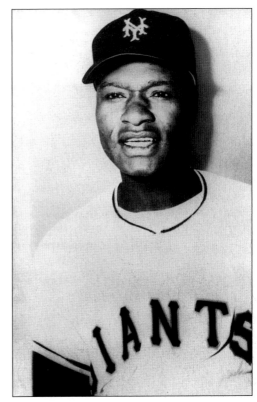

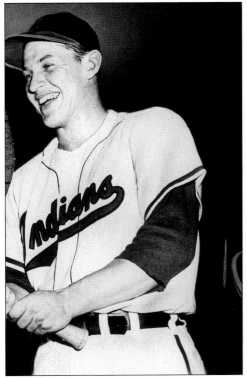

Bob Nieman played for both Oklahoma City and Tulsa on his way to the major leagues. Purchased from Tulsa in 1951, he won the Texas League battle title with a .324 average. Late in the season, the St. Louis Browns bought his contract and promoted him to the big leagues. He was the first player in history to hit home runs in his first two at-bats in the majors. He hit the two homers against Boston's Mickey McDermott at Fenway Park on September 14, 1951. Nieman played 12 years in the major leagues in the outfield. He scouted for the Indians, Dodgers, and White Sox after his retirement as a player. (Oklahoma Publishing Company.)

'Anyway, I'll Bet It's Cool'

Cartoonist Jim Lange chronicled the plight of the Oklahoma City Indians in the late 1940s. For example, the 1946 Indians finished last, 46 games out of first place. (Oklahoma Publishing Company.)

Tommy Tatum (left) was hired as field manager by Indians president Jimmie Humphries, right, for the 1951 season. Tatum managed the Indians for four complete seasons and part of the 1955 campaign. He was a popular redhead who graduated from Oklahoma City's Capitol Hill High School. Known as the "Red Fox," he was the center of attention where Indians baseball fans gathered. Tatum played in 81 major league games in 1941 and 1947. The following year, he led the Texas League in batting and stolen bases playing for Tulsa. Under Tatum, the Indians made the post-season playoffs in 1952 and 1953. After retirement from baseball, Tatum worked in sales at an Oklahoma City radio station and was in the insurance business. (Oklahoma Publishing Company.)

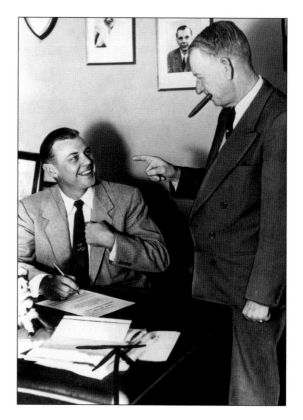

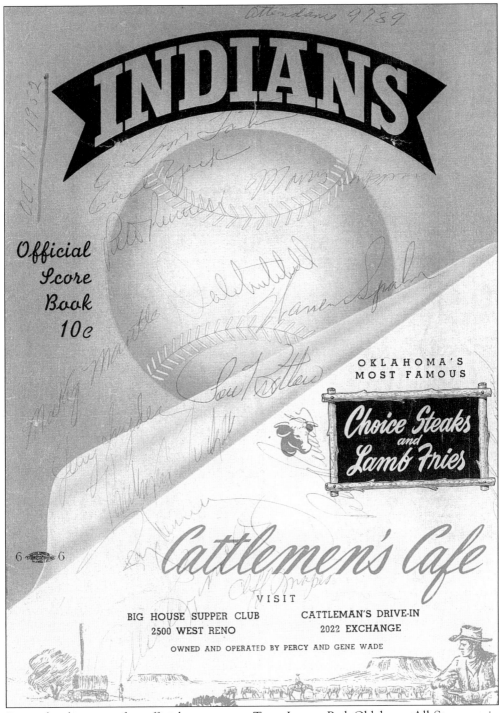

Pictured is the cover of an official program at a Texas League Park Oklahoma All-Star game in October of 1952 between the Allie Reynolds All-Stars and the Warren Spahn All-Stars. (Oklahoma Historical Society.)

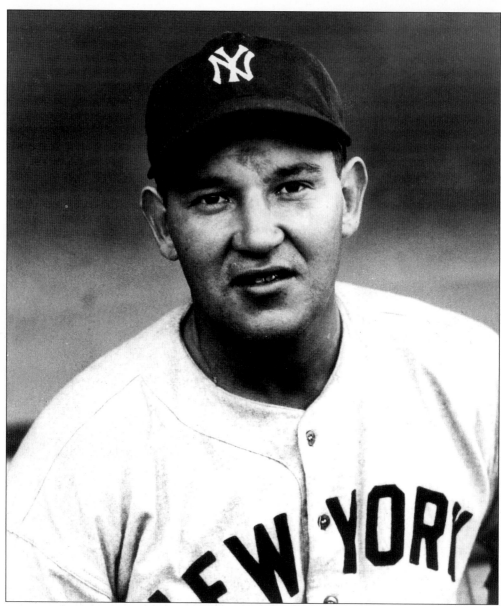

"Super Chief," Allie Reynolds, was born in Bethany, an Oklahoma City suburb, and became one of the greatest New York Yankee pitchers of all time. Joe DiMaggio said in big games, Reynolds was his choice to take the mound. In eight years as a Yankee, Reynolds was on six World Series championship teams. He spent 13 years in the majors with Cleveland and New York. He was the first American League pitcher to toss two no-hitters in the same season, a feat accomplished in 1951. The soft-spoken Creek Indian was proud of his Native American heritage and helped found Red Earth, an annual celebration of Native American culture in Oklahoma City. Reynolds is possibly the best World Series pitcher ever. From 1949 to 1953, when the Yankees won five consecutive championships, he was 7-2 with a 2.79 ERA in World Series games. He is second to Whitey Ford in lifetime World Series wins and second to Rollie Fingers in Series saves. He won the Hickok Belt in 1951 as the nation's best professional athlete. (Baseball Hall of Fame Library.)

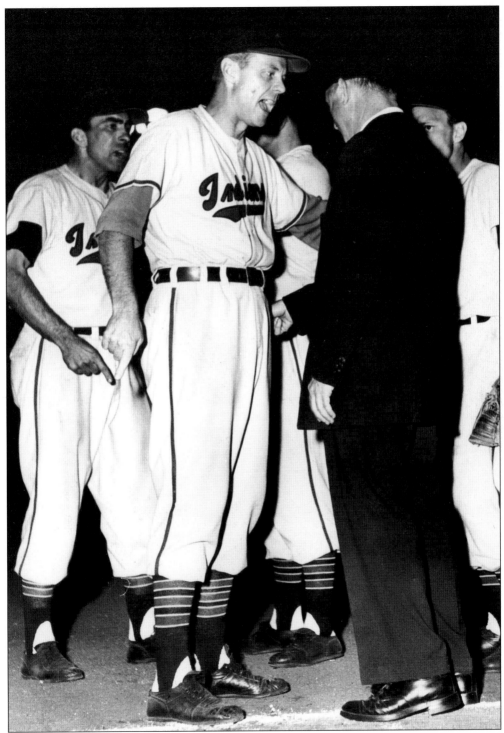

Oklahoma City Indians manager Tommy Tatum gives an umpire a piece of his mind in a 1953 game. Tatum was popular with his players and stuck up for them. Tatum hit .333 to lead the Texas League in batting in 1948. (Oklahoma Publishing Company.)

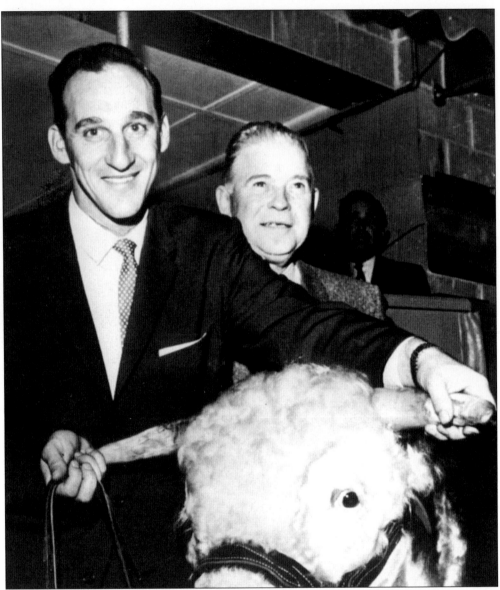

During the off-season, Oklahoman Warren Spahn brought his All-Stars to Texas League Stadium for an exhibition games. He often fielded a team of Oklahoma major league players against a similar squad put together by Yankee pitcher and Oklahoma County native Allie Reynolds. In this photograph, Oklahoma Governor Roy Turner, right, admires a Hereford bull, typical of the cattle raised by Spahn on his ranch near Hartshorne, Oklahoma. Spahn is the winningest southpaw in major league history (363 wins). He was the mainstay of the Braves staff for two decades. His major league career was delayed by service in the Army during World War II and was 25 before winning his first big league game. He led the National League in wins eight times and never had an ERA above 3.50. He was an All-Star seven times. Spahn's lifetime statistics are incredible—he pitched in 750 games and completed 382 of them with a 3.09 ERA. He was also a decent hitter. His 35 career home runs are the most of any National League pitcher in history. Spahn was elected to the Baseball Hall of Fame in 1973. (Oklahoma Publishing Company.)

In 1956, Albie Pearson, a native of California, played for the Oklahoma City Indians. He was only 5'5" and 140 pounds, but he led the Texas League in batting at .371 for the last place Indians. Two years later, playing for the Washington Senators, Pearson was American League Rookie of the Year. He played nine major league seasons with a .270 lifetime batting average. After his retirement from baseball, he became a radio evangelist in southern California. (Oklahoma Publishing Company.)

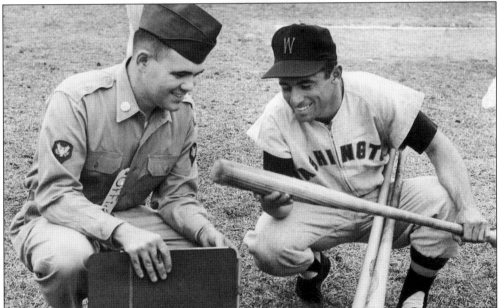

Albie Pearson (right) renews his friendship with Oklahoma City baseball historian Patrick Petree at an exhibition game in 1958 at Fort Gordon, Georgia, where Petree was stationed. Petree got to know Pearson during the 1956 season in Oklahoma City. Petree was the radio voice of the Oklahoma City Indians, broadcast Oklahoma City University basketball games, and worked at a television station in Kansas City, Missouri for nearly a decade before returning to Oklahoma City where he became the official scorer for the Oklahoma City 89ers. In 1981, he authored *Old Times to the Goodtimes*, a history of Oklahoma City baseball. (Patrick Petree.)

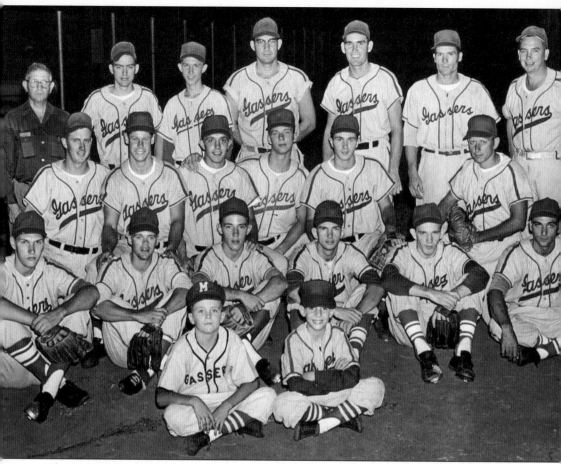

The most popular Oklahoma City sandlot team for decades was the Oklahoma Natural Gas Company Gassers, coached by baseball legend Roy Deal. This is the 1958 version of the Gassers. From left to right are: (front row) batboys Chris Ruscha and Timmy Kline; (second row) Ken Davis, Bill Riddell, David Scruggs, Don Chamberlain, Norris Welker, and Jim Lemons; (third row) Ron Weber, Dave Kimery, Jim Seamans, Joe Melton, Robert Rickey, and Ted Shelby; (back row) manager Roy Deal, Jerry Myers, Steve Kline, Bob Wood, Jack Adams, Melvin Parnell, and Arnodl Cupples. Deal was the first president of the Oklahoma City YMCA baseball program and instilled the love for baseball in lectures to thousands of youngsters. (Oklahoma Publishing Company.)

A very popular Oklahoma City Indian was Thurman Tucker who returned to the city as an insurance agent after nine seasons in the major leagues with the Indians and White Sox. He was the lead off hitter for the American League in the 1944 All-Star game. He played in the outfield for the Oklahoma City Indians in 1940 and 1941 and led the Texas League both seasons in stolen bases. Chicago sportswriters nicknamed him "Joe E.," because of his resemblance to comedian Joe E. Brown. Tucker was one of the fastest runners in the American League before his retirement in 1950. (Oklahoma Publishing Company.)

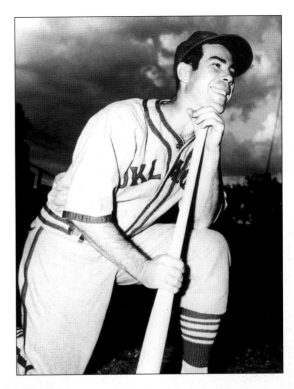

Gene Stephens was groomed to take Ted Williams' place in left field for the Boston Red Sox. Upon the advice of Red Sox and former Oklahoma City Indian announcer Curt Gowdy, Stephens moved to Oklahoma City in the 1950s. At Boston, in the late 1950s, he played in 120 games a season, but batted only about once per game. His primary role was as a late-inning substitute for Williams. In 14 major league seasons as a utility outfielder, Stephens hit .240. In 1953, he set a major league record with three hits in one inning against the Tigers. After his retirement from baseball, Stephens was active in charitable events in Oklahoma sponsored by former major leaguers. (Oklahoma Publishing Company.)

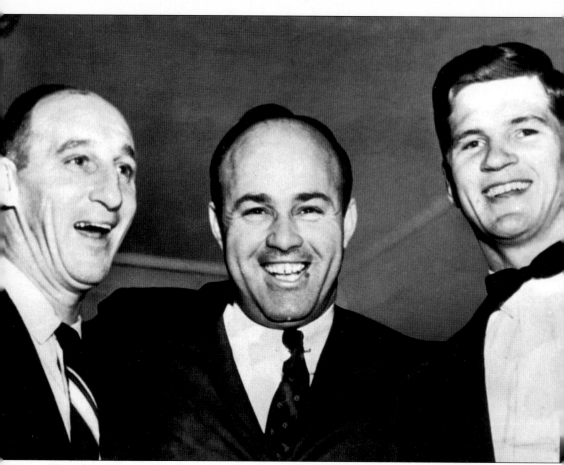

Three baseball legends attended a 1961 dinner in Oklahoma City honoring Oklahoma baseball superstar Mickey Mantle. From left to right are Hall of Famer Warren Spahn, sportscaster and celebrity Joe Garagiola, and New York Yankee pitcher Ralph Terry of Big Cabin, Oklahoma. Terry was famous for two World Series Game Sevens. He gave up a home run to Bill Mazeroski and lost Game Seven to the Pirates in 1960. Two years later, he shut out the Giants in the final game of the Series. Garagiola said about America's pastime, "Baseball is a game where a little guy has got a chance, where a kid who wears glasses has got a chance." (Oklahoma Publishing Company.)

THREE

The 89ers

1962–1997

There was no minor league baseball team in Oklahoma City from 1959 through 1961. However, civic leaders worked behind the scenes to prepare fans for the return of professional baseball. The Oklahoma City Amateur Baseball Association, led by Roy Deal, bought the lights and part of the bleachers of Holland Field and moved them to a spot at the State Fairgrounds for amateur games. The bleachers were set up on land that would ultimately become All Sports Stadium.

In 1961, Houston won a major league baseball franchise and was looking for a Triple A affiliate. Jim Roederer, president of the Oklahoma City All Sports Association, and other civic leaders met with Houston officials and convinced them that Oklahoma City was the appropriate location for the Colt .45s top farm club.

As part of the plan, the Oklahoma City city council approved expenditures in July of 1961 to improve and expand the Fairgrounds ballpark to standards set by the American Association.

The plan came together quickly. Roederer was named the first president of the Oklahoma City team and the stadium was named All Sports Stadium, primarily because of the efforts of the All Sports Association. While the new $275,000 stadium was being built, team officials officed in the Municipal Auditorium.

A contest was arranged to select a new name for the Oklahoma City team. Mrs. Velma Petree, a teacher at Columbus Grade School, was one of 38 people who suggested the team be called the "89ers," in honor of the Land Run of 1889 that opened up much of central Oklahoma to settlement. In her letter recommending the name, Mrs. Petree wrote, "The name 89ers portrays rugged individuals who will put their all into their jobs. It stands for pioneers starting from nothing to build a future. Our 89ers were fighters in a new land and have built our state into one of which we can be proud."

Owen Martiniz, a career baseball executive, was named general manager, and Connie Ryan was hired as field manager of the 89ers, who formally opened in All Sports Stadium April 19, 1962 to a crowd of 10,102. The 89ers did not do well the first season, finishing fifth of six teams, 23 games out of first place. However, attendance of 184,808 was best in the American Association.

In 1963, the American Association suspended play because several of its cities— Milwaukee, Kansas City, Minneapolis, St. Paul, and Houston—had been given major league franchises. Oklahoma City was assigned to the Pacific Coast League and Grady Hatton was named manager. In the new league, the 89ers were contenders from the beginning.

The 89ers won the division title on September 8, 1963, and beat Spokane in a seven-game

series to win Oklahoma City's first professional baseball championship in 28 years. Fan interest was strong for the 89ers in the mid-1960s because of strong pitching by hurlers such as George Brunet, Dave Giusti, Chris Zachary, and Joe Hoerner.

In 1965, the 89ers won another division title and their second PCL championship in three years with a playoff win over Portland. Attendance rose to a record 218,129. Grady Hatton took over the parent Astros as field manager in 1966 and was replaced in Oklahoma City by Mel McGaha, a veteran major league manager. General manager Owen Martinez was replaced by Joe Ryan. McGaha's initial campaign was tough because the best Oklahoma City players from the year before were promoted to Houston or sold. The 89ers finished last in the Eastern Division of the PCL and attendance dropped to 97,761, the lowest since Oklahoma City had entered Triple A baseball.

Oklahoma City native Cot Deal became the 89ers manager in 1968. The next year, the 89ers became part of the reactivated American Association. Former Yankee superstar and Oklahoma Cityan Allie Reynolds was named president of the six-team Triple A circuit.

In 1971, the 89ers were purchased by Tulsa oil man Philip C. Dixon and Dick King became general manager. King had All Sports Stadium repainted, double-decked the outfield fence to increase advertising space, and introduced new player uniforms. Fans responded and turned out in huge numbers. The final attendance count of 329,513 was best in the American Association and a record for Oklahoma City.

Late in 1973, Oklahoma City car dealer W.G. "Bus" Horton bought the 89ers franchise. He named former major leaguer Don Demeter team president. By 1975, unhappy with the players the parent Cleveland Indians were sending to the 89ers, Horton looked for a buyer. He found Harry Valentine, a wealthy Philadelphia businessman looking for a minor league franchise. The 89ers finished the season with less than 600 fans attending each game. Just before Thanksgiving, Horton completed the sale of the team to Valentine.

Valentine secured a player development contract with the Phillies who sent Hall of Famer Jim Bunning to be the 89er manager in 1976. Locally, Valentine hired the Cox Advertising Agency, managed by Patricia Cox and Bing Hampton, to develop a new image for the team. It was the best thing that ever happened to 89er baseball. "Goodtime Baseball" was the theme of a strong media campaign. Fans were happy with the changes and came back to the ballpark.

Ownership changed again in 1978. Cox and Hampton put together a group of local investors including Allie Reynolds to purchase the club from Valentine. Patty Cox, the new general manager, was named baseball's Woman Executive of the Year that year. Attendance soared. Hampton was in charge of sales that ranked near the top of all minor league operations. He also was the popular public address announcer at All Sports Stadium.

In 1978, pitcher Jim Warthen won the Allie Reynolds Award, given to the top pitcher in the American Association each year. He followed 89er hurlers Jim Kern, John Montague, and Jim Wright who had won in three of the previous four years.

In 1979, the 89ers won their first American Association division crown under manager Lee Elia but lost the pennant in a playoff against Evansville. The largest crowd in Oklahoma City baseball history, 18,543 (a record later broken), watched an exhibition game between the 89ers and the Phillies.

The 89ers became the top farm club for the Texas Rangers in 1983. Fan interest was high because of the close proximity to the parent club in nearby Arlington, Texas. With an influx of quality players, Oklahoma City won another division crown in 1985.

In 1989, Hampton was battling Lou Gehrig's disease. He and his wife, Patty Cox Hampton, sold the 89ers to a New York investment group headed by Jeffrey H. Loria, a wealthy art dealer. Oklahoma City native and Yankee star Bobby Murcer was one of the investors.

Throughout the late 1980s, the 89ers finished at or near the bottom of their American Association division. However, in 1992, Oklahoma City again won the division title and swept Buffalo for the pennant.

In 1993, a local investment group headed by the Oklahoma Publishing Company and

furniture dealers Bill and Larry Mathis purchased the 89ers for $8 million, believed to be the highest price ever paid for a minor league franchises. Publisher Edward L. Gaylord was the moving force to keep minor league baseball in Oklahoma City.

In 1996, the 89ers came from last place in June to win the American Association pennant.

Talk of a major downtown redevelopment plan and the possible construction of a new minor league ballpark renewed interest in Oklahoma City's baseball franchise in 1996. Because of incredible local involvement, a new era in baseball would be launched and 1997 would be the last year Oklahoma City's entry into the little show would be called the 89ers.

Year	Team	Finish	W	L	League	Manager	Affiliate
1962	89ers	5 of 6	66	81	American Assn.	Ryan	Houston
1963	89ers	1 of 5	84	74	PCL	Hatton	Houston
1964	89ers	3 of 6	88	70	PCL	Hatton	Houston
1965	89ers	1 of 6	91	54	PCL	Hatton	Houston
1966	89ers	6 of 6	59	89	PCL	McGaha	Houston
1967	89ers	4 of 6	74	74	PCL	McGaha	Houston
1968	89ers	6 of 6	61	84	PCL	Deal	Houston
1969	89ers	5 of 6	62	78	American Assn.	Deal	Houston
1970	89ers	3 of 4	68	71	American Assn.	Kittle	Houston
1971	89ers	2 of 4	71	69	American Assn.	Williams	Houston
1972	89ers	4 of 4	57	83	American Assn.	Pachecho	Houston
1973	89ers	3 of 4	61	74	American Assn.	Lucchesi	Cleveland
1974	89ers	3 of 4	62	74	American Assn.	Davis	Cleveland
1975	89ers	4 of 4	50	86	American Assn.	Davis	Cleveland
1976	89ers	2 of 4	72	63	American Assn.	Bunnning	Philadelphia
1977	89ers	3 of 4	70	66	American Assn.	Ermer/Ryan/Connors	Philadelphia
1978	89ers	3 of 4	62	74	American Assn.	Ryan	Philadelphia
1979	89ers	1 of 4	72	63	American Assn.	Elia	Philadelphia
1980	89ers	2 of 4	70	65	American Assn.	Snyder	Philadelphia
1981	89ers	3 of 4	69	67	American Assn.	Snyder	Philadelphia
1982	89ers	4 of 4	43	91	American Assn.	Clark/Deal/Taylor	Philadelphia
1983	89ers	2 of 4	66	69	American Assn.	Burgess	Texas
1984	89ers	7 of 8	70	84	American Assn.	Burgess/Gerhardt	Texas
1985	89ers	1 of 4	79	63	American Assn.	Oliver	Texas
1986	89ers	4 of 4	63	79	American Assn.	Oliver	Texas
1987	89ers	4 of 8	69	71	American Assn.	Harrah	Texas
1988	89ers	4 of 4	67	74	American Assn.	Harrah	Texas
1989	89ers	4 of 4	59	86	American Assn.	Skaaleen	Texas
1990	89ers	4 of 4	58	87	American Assn.	Smith	Texas
1991	89ers	4 of 4	52	92	American Assn.	Thompson	Texas
1992	89ers	1 of 4	74	70	American Assn.	Thompson	Texas
1993	89ers	4 of 4	54	90	American Assn.	Jones	Texas
1994	89ers	7 of 8	61	83	American Assn.	Jones	Texas
1995	89ers	8 of 8	54	79	American Assn.	Biagini	Texas
1996	89ers	2 of 4	74	70	American Assn.	Biagini	Texas
1997	89ers	3 of 4	61	82	American Assn.	Biagini	Texas

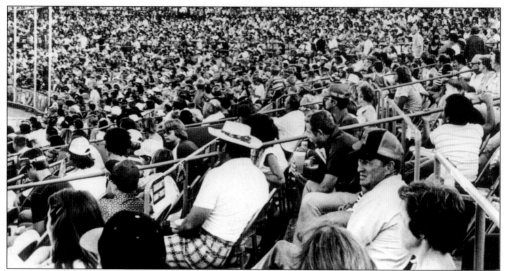

All Sports Stadium at the State Fairgrounds was unveiled as the new home of the 89ers in 1962. The new stadium resembled in many ways the old Texas League Park. Home plate was in the southwest corner and spectators had a good view of the downtown skyline beyond the right field fence. However, the playing field in the new park was more spacious—340 feet down the foul lines and 415 feet to center field. A $48,000 scoreboard was placed in left field. Seating capacity was 10,000, with 6,000 permanent seats built immediately. A new lighting system, banks of 500 bulbs, lit up the night sky for evening games. The stadium was completed literally as the 89ers prepared for their first game. Trucks sprinkled water on the approach roads and electricians finished their work on lighting the restrooms and concession booths. (Oklahoma Publishing Company.)

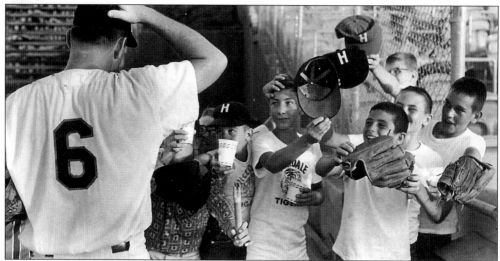

Oklahoma City baseball fans were overjoyed with the return of minor league action to the capital city in 1962. Joe Wooten, an 89er catcher, wonders where to start as young fans besiege him for autographs before a game in the 89er inaugural season. The 1962 campaign was not successful—the 89ers finished fifth, 23 games behind first place Indianapolis. However, the finish was better than some expected, considering the fact that Houston was building its major league team and farm system from scratch. (Oklahoma Publishing Company.)

56

Connie Ryan (right), the 89ers first field manager, expresses a difference of opinion with umpire John Kibler over a catcher's interference call in a 1962 89ers game. Ryan managed the 89ers to a 66-81 record in their first season. Most considered his job well done because the 89ers were the victim of a swinging door for players as Houston tried to build an expansion team. Ryan hit .248 lifetime in a dozen seasons in the major leagues. He made the 1944 National League All Star team. He appeared in two games for the Boston Braves in the 1948 World Series. After his stint at the helm of the 89ers, Ryan coached for Atlanta and Texas and managed the Braves briefly in 1975 and 1977. (Oklahoma Publishing Company.)

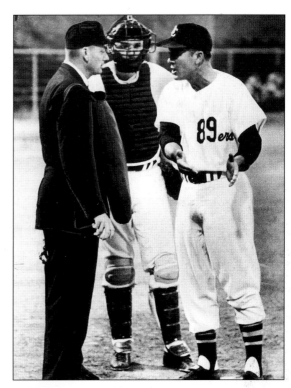

George Brunet was 27 years old when he joined the 89ers in 1962. The following year, he won 18 games as the 89ers won the PCL championship. He pitched at least part of the next several seasons for the 89ers. In 1964, he was 8-3 with a 2.07 ERA for Oklahoma City. He appeared in more than 300 major league games in 15 different seasons, making more than 30 minor and major league moves. He was a hard luck pitcher, losing 19 games in 1967 and 17 games in 1968, despite having a respectable ERA of 3.31 and 2.85 for the California Angels who could not score runs. In 15 of Brunet's losses in 1967, the Angels scored two runs or less. (Oklahoma Publishing Company.)

Tom Borland, a native of McAlester, Oklahoma, was a bullpen ace for the 89ers in 1962 and 1963. Before professional baseball, he was an All-American hurler at Oklahoma A & M (now Oklahoma State University) and was named the outstanding player in the 1955 College World Series. He signed a $40,000 bonus with Baltimore and appeared in two dozen games for Boston in 1960 and 1961. After he was traded to Houston, he was assigned to Oklahoma City. Borland combined with Ben Johnson to pitch a nine-hit shutout as the 89ers won the final game of the 1963 PCL playoffs at All Sports Stadium. (Oklahoma Publishing Company.)

Named Oklahoma City's most popular player with the fans in 1962, Dave Roberts rounds third base after blasting a two-run homer against Denver in a game in August of 1962. Bob Hersom of *The Daily Oklahoman* said Roberts was the greatest player in 89er history. In 1962, Roberts was second in the league batting race with a .322 average and led the league in doubles with 38. In 1965, he led the league in home runs with 38, batted .318, drove in 114 runs, and was the league's Most Valuable Player. Roberts' home run output in 1965 still stands as the best homer year for a Triple A player in Oklahoma City. In his four seasons with the 89ers, he hit .309 with 99 doubles, 74 home runs, and 326 RBIs. The first baseman, a native of Panama, played professional baseball for 22 seasons, the final seven years in Japan. He spent part of three major league seasons with Houston and Pittsburgh. (Oklahoma Publishing Company.)

In 1963, Dave Giusti struck out 165 hitters and posted a 2.72 ERA for the 89ers, second best in the league. He was 10-6 the following season before being called up to Houston. He was palmball artist as a reliever in 15 major league seasons with six clubs. He led the National League with nine relief wins for the Pirates in 1970. In 1971, he won the title of Fireman of the Year with 30 saves. That same year, he became the first pitcher in the history of baseball to appear in every game of a four-game League Championship Series—he had three saves. As an 89er, Giusti struck our 324 batters, third on the all-time 89ers pitching list. (Oklahoma Publishing Company.)

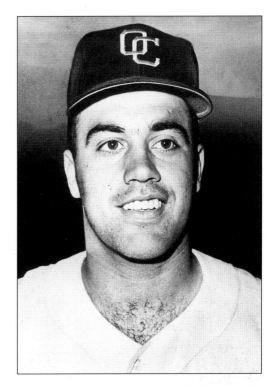

In 1963, the 89ers second season, Grady Hatton, who played 12 years in the majors, was named field manager. He is the only Oklahoma minor league manager to win two pennants—in 1963 and 1965. Hatton was 263-198 as manager of the 89ers. After three seasons in Oklahoma City, Hatton was promoted to manage the Houston Astros. In 1965, surrounded by many of his former Oklahoma City players such as Dave Giusti, Joe Hoerner, George Brunet, Jimmy Wynn, and John Bateman, Hatton led the Astros to a 72-90 record, the best in their five-year history. He managed the Astros for three years. (Oklahoma Publishing Company.)

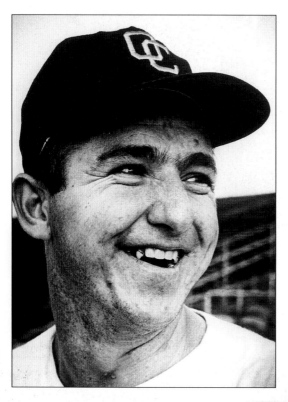

John Bateman played for the 89ers in 1964 and 1965 after breaking into the major leagues in 1963 with Houston. He played for Houston until 1969 when he was traded to Montreal. He was a steady catcher who closed out his career with the Phillies in 1972. Bateman's best major league year was 1966 when he hit .279 and slugged 17 homers for the Astros. He hit the last homerun in Connie Mack Stadium in Philadelphia when the field closed in 1970. In the 1970s, after retirement, Bateman barnstormed with Eddie Feigner's softball team. (Oklahoma Publishing Company.)

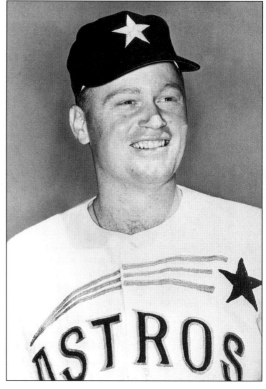

Houston sent young Rusty Staub to Oklahoma City for development in 1963 and 1964. He played nearly 3,000 games in the majors over 23 seasons for Houston, Montreal, New York, Detroit, and Texas. He is among only 13 players to participate in games in 23 different seasons in the big leagues. He hit .279 lifetime with 292 homers. He was a superb batter, garnering 2,716 career hits. His home run off Ken Holtzman won Game Four of the 1973 World Series. (Oklahoma Publishing Company.)

Jimmy Wynn was hitting .363 for the 89ers in 1964 when he became part of the swinging door and was called up to the Houston Astros. He was the first slugging star for the new Houston entry in the National League. The speedy outfielder spent 11 seasons in Houston and led the team in almost every offensive category. After he was stabbed in the stomach in 1970, Wynn recovered and set a Dodger record with 32 home runs. The feat won his Comeback Player of the Year honors from *The Sporting News*. He played for Houston, Los Angeles, Atlanta, and Milwaukee in 15 major league seasons and hit .250 lifetime. (Oklahoma Publishing Company.)

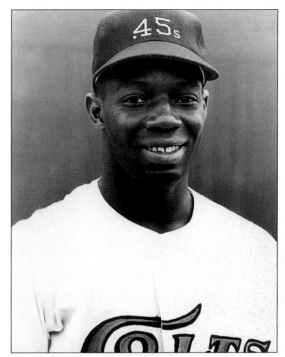

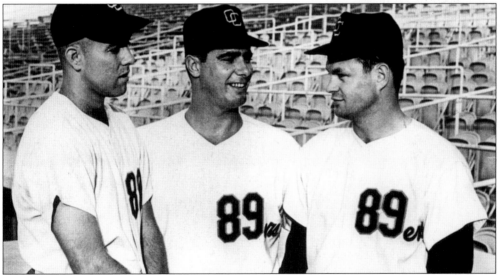

Three players for the 1964 89ers were, from left to right, Jim Beauchamp, George Brunet, and Joe Hoerner. Beauchamp hit a towering home run at All Sports Stadium in 1964 so far that the ball was never found. He hit 34 homers that year after being named the Texas League Most Valuable Player the previous season playing for Tulsa. In his ten years in the big leagues, Beauchamp was primarily used as a pinch hitter. Hoerner pitched for the 89ers in four different seasons from 1962 to 1965. He appeared in 51 games in relief for the 89ers in 1963 with a 1.31 ERA. During the 1965 pennant-winning year, Hoerner was 8-3 for the 89ers. He pitched in the big leagues for 14 seasons. In 1968, he tied a National League record for relievers by striking out six consecutive batters. The following year, he was part of the famous Curt Flood trade. Hoerner never gave up a hit to Hank Aaron in 22 chances. (Oklahoma Publishing Company.)

Don Hodges was the public address announcer at All Sports Stadium from 1963 to 1969. He remembers a night charged with excitement when Bo Belinsky was pitching for the visiting Hawaii Islanders. Belinsky had pitched a no-hitter earlier in the year for the California Angels and had been become the "playboy" of baseball. The most exciting player Hodges ever saw was Bobby Bonds, playing for the Phoenix Giants in a series against the 89ers. (Don Hodges.)

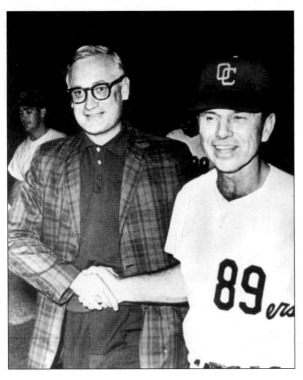

Jim Roederer (left) president of the 89ers, congratulates manager Grady Hatton after the 89ers clinched the 1965 PCL Eastern Division championship. (Oklahoma Publishing Company.)

Sonny Jackson hit a whopping .330 at shortstop for the 89ers in their pennant-winning season in 1965, second best in the league. He stole his 52nd base of the season on September 2 when the 89ers clinched their division. It was a great day for Jackson because his wife had given birth to a baby girl that afternoon, almost making Jackson late to the game. He holds the all-time Triple A Oklahoma City minor league record of 193 hits in a season. He hit .292 and stole 49 bases in his first full season for the Astros, a National League rookie record. He played most of his 12 years in the majors in the outfield. He scouted for the White Sox and coached in the Braves' minor league operation after retirement as a player. He became a coach for the San Francisco Giants in 1997. (Oklahoma Publishing Company.)

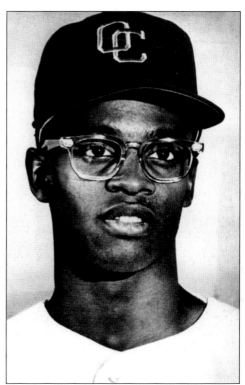

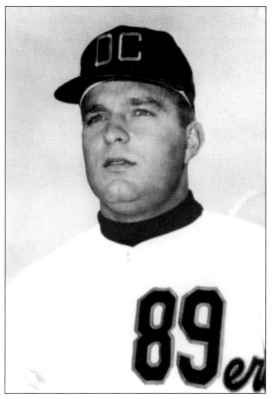

Chris Zachary's 17 wins for the 89ers in 1965 is second best on the all-time list. He had 266 strikeouts in two seasons with Oklahoma City. In 1965, he won the game in September against San Diego that clinched the division title and pitched a five-hitter to win the final playoff game against Portland. The 89ers overcame a 3-1 deficit with five runs in the eighth to win the championship. Zachary pitched nine seasons in the major leagues but never had a winning percentage. His best season was 1972 when he had a 1.42 ERA in 25 games and helped the Tigers win a division championship. (Oklahoma Publishing Company.)

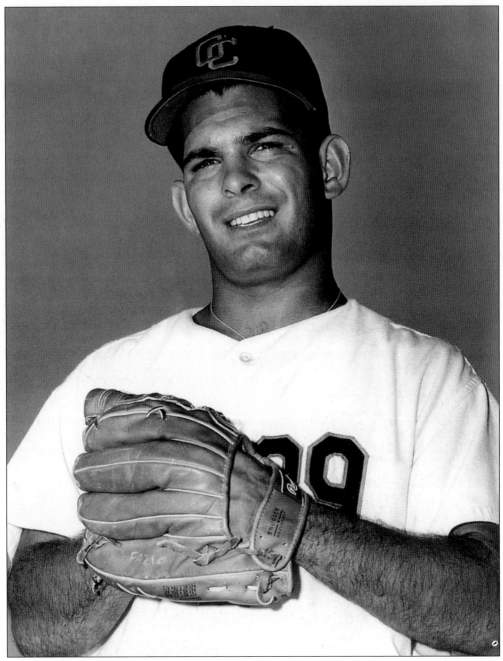

Ernie Fazio was a young shortstop who became one of the all-time favorite players of 89er fans. He played on spirited teams in 1964 and 1965 for manager Grady Hatton. In 1964, Hatton called Fazio and his teammates, including Jimmy Wynn, John Bateman, Jim Beauchamp, Rusty Staub, Sonny Jackson, and Dave Giusti, his most talented squad. Fazio won the hearts of Oklahoma Cityans when he married a local girl. (Oklahoma Publishing Company.)

Mike Brumley, a native of Granite, Oklahoma, played for the Oklahoma City 89ers, and three years with the Washington Senators. He later managed in the Diamondbacks' Rookie League in Peoria. His son, Anthony Michael Brumley, was born in Oklahoma City and played eight major league seasons with the Astros, Mariners, Red Sox, Athletics, and Tigers. The younger Brumley, often confused with his father because of baseball cards calling both of them "Mike," retired after the 1995 season. (Oklahoma Publishing Company.)

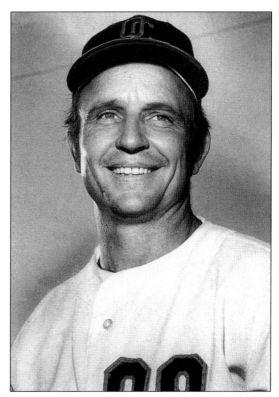

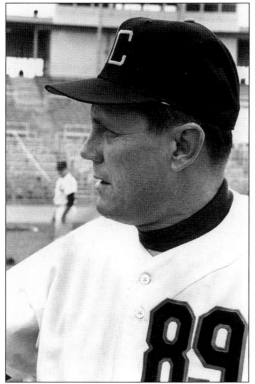

Mel McGaha was field manager for the 89ers in 1966 and 1967, finishing sixth and fourth in their division. The 1967 club played .500 baseball with a record of 74-74. McGaha was a veteran major league manager, having skippered both Cleveland and Kansas City in the American League. He was a former University of Arkansas basketball, baseball, and football star who was familiar to 89er fans because of his years as manager of the Shreveport Sports in the Texas League in the 1950s. McGaha had a tough assignment because most of the players from 1965 had either been promoted to the majors or sold. His 1967 squad finished fourth in the division but had been in contention for the division title as late as August. (Oklahoma Publishing Company.)

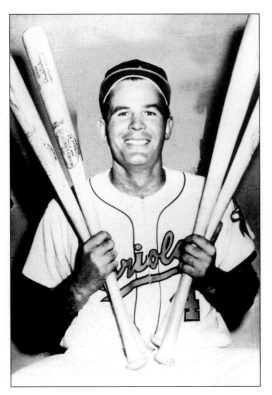

Sent to Oklahoma City by Houston at the end of a solid nine-year major league career, Jim Gentile played first base for the 89ers in 1966. "Diamond Jim" had a huge year in 1961, hitting 46 home runs, although he was overshadowed by Roger Maris' 61 and Mickey Mantle's 54 homers. Also in 1961, Gentile set a major league record, five grand-slam homers in a season, which stood for 26 years. He hit two of the grand-slams on consecutive pitches in one game. He also set an American League record of eight RBIs in consecutive innings. He was an American League All Star from 1960 through 1962 and finished third, behind Maris and Mantle, in the Most Valuable Player balloting in 1961. He married an Oklahoma girl and settled in Edmond after his retirement as a player and tour as a coach for San Diego of the Pacific Coast League. In this photograph, he holds four bats, symbolizing four grand-slams he had hit through July 7 of 1961. He added a fifth later, giving him the long-standing record. (Oklahoma Publishing Company.)

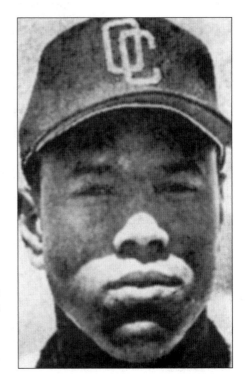

Bob "Bull" Watson once started a rhubarb after being called out on strikes during a 1968 89er game. He played in the outfield for Oklahoma City before jumping to the majors where he logged 19 big league seasons with the Astros, Red Sox, Yankees, and Braves. He hit .295 lifetime with 184 home runs and 989 RBIs. In 1976, he scored the one-millionth run in major league history. As a designated hitter in 1979, he became the first player in the majors to hit for the cycle in both leagues. Watson tied a World Series record by hitting a homer in his first at-bat in the 1981 Series. He became general manager of the Houston Astros in 1993. (Oklahoma RedHawks.)

Leading the 1967 89ers in hitting was Ivan Murrell, a native of Panama, who was named that year to the Pacific Coast League All-Star team. He was PCL player of the month in July of 1967 when he went on a torrid hitting streak. He played ten seasons in the big leagues with Houston, Atlanta, and San Diego. He hit .245 with 12 homers, 35 RBIs, and 41 runs scored in 1970, his best major league season. (Oklahoma Publishing Company.)

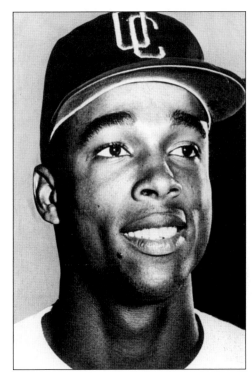

Doug Rader was the starting third baseman for the 1967 89ers. He was freckle-faced, wild, and eccentric and earned the nickname, "The Red Rooster." Late in the season, Rader was called up to Houston where he began an 11-year major league career. From 1970 to 1974 he won five consecutive Gold Gloves and hit more than 20 homers in three of the seasons. In 1983, he was named manager of the Texas Rangers. Later, he managed briefly for the White Sox and three years for the Angels. His seven years as a field manager and 11 campaigns as a player gave him nearly two decades of major league experience. (Oklahoma Publishing Company.)

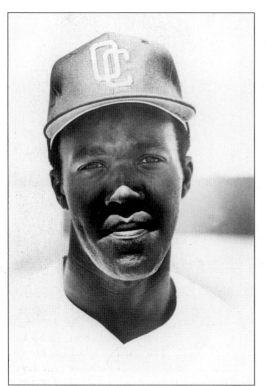

Nate Colbert's two-out single in the tenth gave the 89ers an exciting opening day win over Phoenix in 1968. He returned to the parent Astros later in the season where he had begun his big league career in 1966. The San Diego Padres chose him ninth in the 1968 expansion draft. In 1972, he led National League first basemen in assists and drove in nearly one-fourth of all Padre runs and accounted for one-third of the team's home run production. From 1971 to 1973, he as named to the All-Star team. In 1972, he set a major league record in a doubleheader in Atlanta by driving in 13 runs. He also tied a Stan Musial record of five homers in a twin-bill. (Oklahoma Publishing Company.)

Danny Walton is the only Oklahoma City 89er ever named Minor League Player of the Year by *The Sporting News*. He hit .332 for the 89ers in 1969, fourth best in the league, and established the all-time Oklahoma minor league high of 119 RBIs. He also homered 25 times that season. Walton was traded to Seattle in 1970 and was among league leaders in home runs and RBIs until a knee injury cut short his season. He played nine years in the big leagues with the Astros, Mariners, Brewers, Yankees, Twins, Angels, and Rangers. His lifetime batting average was .223. (Oklahoma Publishing Company.)

Two of Oklahoma City's best-known major league stars, Allie Reynolds (left) and Bobby Murcer. Reynolds became president of the American Association in 1969 and was an integral player in Oklahoma City minor league baseball. Murcer, a native of Oklahoma City, spent much of his childhood at the old Texas League Park watching the Oklahoma City Indians. After starring as an All-State quarterback at Oklahoma City's Southeast High School, he broke into major league baseball at age 19, destined to replace fellow Oklahoman Mickey Mantle in centerfield for the Yankees. Murcer is the only Yankee, besides Lou Gehrig, to hit four consecutive home runs. In 1971, he hit .331, second in the American League. In his first five seasons, he hit at least 22 home runs. From 1971 to 1975, he was named to the American League All-Star Team. In 1973, he became the youngest player in history to make $100,000 a year. In 17 seasons with the Yankees, Giants, and Cubs, he hit 252 home runs and batted .273. After retirement as a player, Murcer went to the broadcast booth for the Yankees. When Murcer was a part owner of the 89ers in the early 1990s, he helped out on 89er broadcasts. (Oklahoma Publishing Company.)

Cot Deal, a major name in Oklahoma City baseball for 40 years, was the field manager for the 89ers in 1968 and 1969. He had served as pitching coach for Houston and Kansas City before taking the Oklahoma City post. He was part of a legendary baseball family, the son of Roy Deal who managed the semi-pro Oklahoma Natural Gas Gassers and promoted baseball from little league to Triple A. Deal pitched four years in the majors for the Red Sox and Cardinals after a brilliant sandlot career for Enid, Oklahoma's team. He is the only person in National Baseball Congress history to win the annual tournament MVP award twice. Deal was highly regarded as a major league coach for Houston, Kansas City, Detroit, Cleveland, and the Yankees. (Oklahoma Publishing Company.)

One of the all-time favorites of 89er fans was John Mayberry who batted .303 with 21 homers for Oklahoma City in 1969. At 6'2" and 220 pounds, he was an agile first baseman who began a solid 15-year major league career after his tour for the 89ers. He batted .253 lifetime in 1,620 big league games with the Astros, Royals, Blue Jays, and Yankees. He was a slugger, hitting 20 homers in eight seasons and 30 round-trippers twice. He hit three home runs in a game on two occasions. He was voted to the National League All-Star team in 1973 and 1974. He led the American League in putouts three times and twice in double plays and fielding. (Oklahoma Publishing Company.)

Cesar Cedeno had an impressive short stay with the 89ers in 1970. He played 64 games until called up to Houston to begin a 17-year career in the majors. He was an All-Star four times, hit 199 home runs, and stole 550 bases in his seasons with the Astros, Reds, Cardinals, and Dodgers. Cedeno twice led the National League in doubles, stole over 50 bases six times, batted .320 twice, and won five Gold Glove Awards. In 1988, he tried a comeback with the 89ers but left spring training camp and told a reporter, "My legs can't take it anymore." (Oklahoma Publishing Company.)

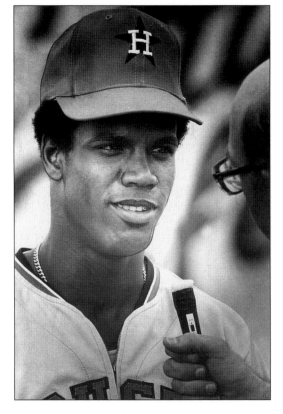

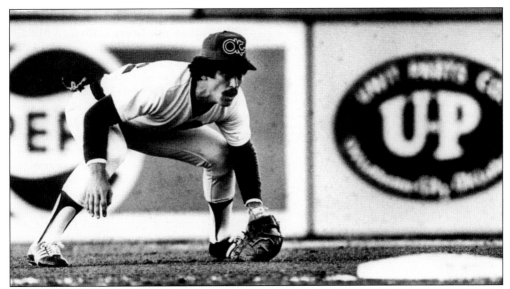

At third base for the 89ers in 1970 was John Vukovich who then made the jump to the big leagues with the parent Houston Astros. In the majors, he spent 10 seasons as a utility infielder. He returned to the 89ers in 1979 and had a brilliant year. Vukovich was field manager briefly for the Cubs in 1986 and the Phillies in 1988. As a first and third base coach for Philadelphia in the 1990s, he was considered by some to be one of the best baseball minds in the game. (Oklahoma Publishing Company.)

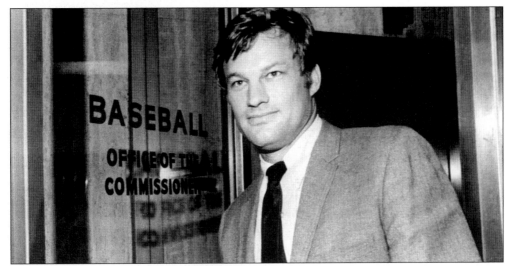

Jim Bouton, infamous for his tell-all book, *Ball Four*, came to Oklahoma City in 1970 in a comeback attempt, sent to the 89ers by Houston to help out a sagging pitching staff. However, Bouton gave up 11 runs and 14 hits in losing both his 89er appearances. He pitched sparingly in 304 major league games in ten seasons. Early in his career, in 1963, he was an All-Star pitcher and won 21 games for the Yankees. The following year, he won 18 games, including two over the Cardinals in the World Series. In 1965, he blew out his arm and never was a star after that. Although best known in the baseball world for *Ball Four*, Bouton is credited with inventing "Big League Chew," bubblegum shredded to resemble chewing tobacco. (Oklahoma Publishing Company.)

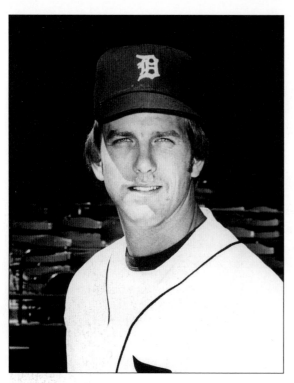

Milt Wilcox was a baseball and basketball star at Oklahoma City's Crooked Oak High School. He turned down a baseball scholarship at the University of Oklahoma to turn pro. He was a freckle-faced 20 year old when he won the deciding game for the Reds in the 1970 National League Championship Series. He was 2-0 and never allowed a run in 11 innings in two NLCS appearances. Wilcox pitched in more than 2,000 big league games over 16 seasons for the Reds, Indians, Cubs, Tigers, and Mariners. He nearly pitched a perfect game on April 15, 1983. With two outs in the ninth, pinch-hitter Jerry Hariston singled. (Oklahoma Publishing Company.)

James Rodney Richard's 2.45 ERA for the 89ers in 1971 is the best ever for a Triple-A pitcher in Oklahoma City. Considered by many observers to have the most velocity on a fastball in baseball history, Richard ranks near the top in strikeouts for the 89ers. He fanned 371 opposing batters in two seasons. In 1971, he led the American Association with a 12-7 record and 207 strikeouts. After moving to the majors, he played ten seasons. He struck out 15 batters in his major league debut, tying a big league record. With a big stride from his 6'8" frame, he intimidated hitters. He won 20 games for Houston in 1976 and 18 each year from 1977 to 1979. He topped the senior circuit with 303 strikeouts in 1978 and 1979 when he also led the league with a 2.71 ERA. He complained of a "dead arm" and was given grief by fans and the media. However, it was later discovered he had a stroke which ended his pitching career. (Oklahoma Publishing Company.)

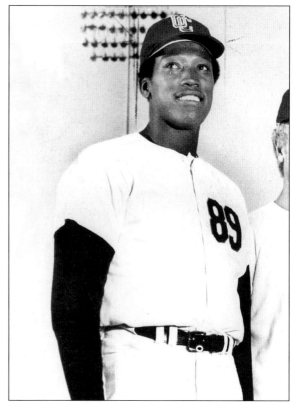

Oklahoma City native Don Demeter (right) played 11 seasons in the major leagues and retired at age 31, to spend more time with his growing sons. He graduated from Capitol Hill High School and played in the big leagues with the Dodgers, Phillies, Tigers, Red Sox, and Indians. He hit .265 lifetime with 163 homers. His best season was 1962 when he hit .307 with 29 home runs for Philadelphia. He twice hit three homers in a game. He set a major league record for outfielders with 266 consecutive error free games from September of 1962 through July of 1965. In 1973, Demeter became president of the 89ers, taking time off from a successful swimming pool installation business. For years, he held chapel services for the 89ers and was an associate pastor of a south Oklahoma City Baptist church. In this photograph with Demeter is his son Todd, the 1979 Oklahoma high school player-of-the-year who was the Yankees' first draft choice. Todd played six years in the minors and then tragically died in 1996 of Hodgkins Disease. (Oklahoma Publishing Company.)

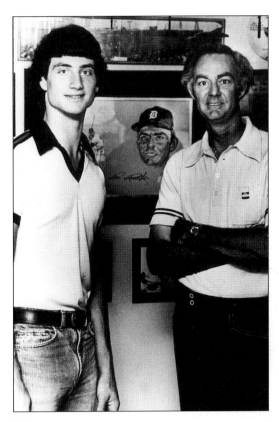

Rick Cerone played for the 89ers in 1974, sent to Oklahoma City by the Cleveland Indians for development. The following year, he began a good 18-year career in the majors, playing in 1,329 games for the Indians, Blue Jays, Yankees, Braves, Brewers, Red Sox, Mets, and Expos. He hit .245 lifetime as a catcher. He was a crowd favorite at Yankee Stadium because he grew up in nearby New Jersey. In the 1990s, he became the media relations director for the Yankees. His best big league season was 1980 when he hit .277 with 14 homers and 75 RBIs, placing him seventh in the American League Most Valuable Player balloting. (Oklahoma Publishing Company.)

Based upon a 17-7 record, 220 strikeouts, and 2.52 ERA, Jim Kern won the Allie Reynolds Award as the best pitcher in the American Association in 1974. He appears often in the 89er record book—most complete games in a season, second in ERA, second in single season wins, and first in strikeouts. He pitched 13 seasons in the majors with a lifetime 3.32 ERA. He was nicknamed "Emu" because of his 6'5" frame. From the bullpen, he was the 1979 Fireman of the Year in the American League, winning 13 games with 29 saves and a 1.57 ERA. (Oklahoma Publishing Company.)

Oklahoma's greatest baseball star was Mickey Mantle, seen here signing autographs at All-Sports Stadium in Oklahoma City in 1975. He often appeared at 89er and old-timer games to honor fellow Oklahomans such as Allie Reynolds and Lloyd Waner. He grew up in Commerce, Oklahoma, and played his entire 18-year major career as a New York Yankee. "The Mick" hit .298 lifetime with 536 homers and became an icon for baseball fans everywhere. He won the Triple Crown in 1956, batting .353 with 52 homers and 130 RBIs. He capped the year with three home runs in the World Series, including the winning blow in Don Larsen's perfect game. Mantle hit some of the longest home runs in baseball history, giving rise to the phrase "tape measure home run." Playing on bad legs, Mantle set many World Series records. No baseball fan alive in 1961 will ever forget his race with Roger Maris for Babe Ruth's home run record. He was inducted into the Baseball Hall of Fame in 1974. (Oklahoma Publishing Company.)

Duane Kuiper hit .310 and led the American Association in stolen bases (28) in 1974. In the final month of the season, he was called up to Cleveland and began a dozen years in the majors, primarily as a second baseman. He twice led American League second basemen in fielding percentage. He was not a power hitter, slugging only one homer in 3,379 appearances at the plate. However, he was a disciplined hitter, three times getting the only hit in a game. He broke up no-hitters for Ron Guidry, Nolan Ryan, and Andy Hassler. (Oklahoma Publishing Company.)

John Montague (left) is presented the Allie Reynolds Trophy as the American Association's top pitcher in 1976 by 89er owner Harry Valentine. Montague posted a 14-6 record with an ERA of 2.65 for the 89ers. (Patrick Petree.)

75

Bing and Patty Cox Hampton were vital to the success of minor league baseball in Oklahoma City. They were hired in 1976 to develop a new image for the 89ers. They created "Goodtime Baseball" as a media theme and successfully promoted, managed, and owned the ball club for more than a decade. Patty was Baseball's Woman Executive of the Year in 1978 and the American Association Executive Award winner in 1978 and 1979. Bing and Patty kept fans informed, especially when financial difficulties threatened Oklahoma City with the loss of a minor league club. (Patrick Petree.)

George Frazier was born in Oklahoma City and won 13 of 18 decisions for the University of Oklahoma before being drafted by the Milwaukee Brewers. He jumped to the big leagues after three years in the minors. He pitched ten years in the majors, ending his career on a high note, tossing two shutout innings for the champion Minnesota Twins in Game Four of the 1987 World Series. He had a record-setting year in 1981. The good news was he fanned five batters in 5 2/3 innings in the ALCS, the most strikeouts ever by a pitcher in a LCS. The bad news was that he lost three games for the Yankees in the World Series, also a record. After retirement from baseball, he ran a sporting goods store in Tulsa and was a broadcaster for the Colorado Rockies. (Oklahoma Publishing Company.)

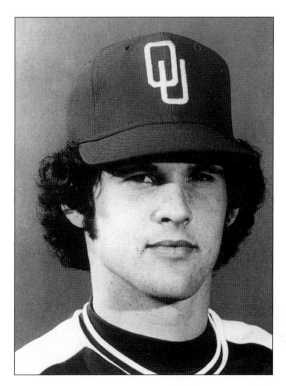

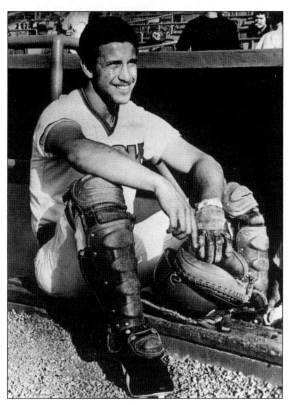

A super popular catcher for the 89ers in 1976 was Bill Nahorodny. "Naha" hit 23 home runs that year and was voted by the fans as the Most Popular 89er. He spent nine years in the big leagues with the Phillies, White Sox, Braves, Indians, Tigers, and Mariners. He hit .241 lifetime with 25 homers. Nahorodny's only season as a regular behind the plate was 1978 when he caught 104 games and hit .236 with eight homers and 35 RBIs. In this photograph, "Naha" relaxes with the tools of his trade, his mitt and batting helmet, before a game against Evansville in July of 1976. (Oklahoma Publishing Company.)

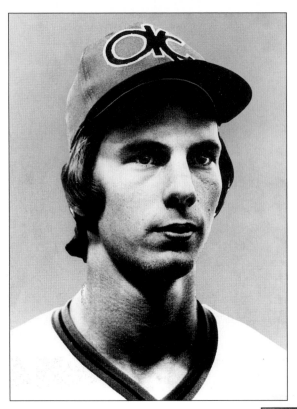

Philadelphia sent Randy Lerch to the 89ers in 1976 where he promptly won 13 games and led the American Association with 152 strikeouts. He was 13-11 with a 3.35 ERA and tied teammate John Montague for most complete games with 11. Lerch pitched in the majors for 11 seasons. He led National League pitchers with three home runs in 1978. He hit two round-trippers against the Pirates in a game in September to give the Phillies the division title. Lerch was 6'5" and pitched well in the majors until he broke a bone in his wrist in 1979. (Oklahoma Publishing Company.)

Baseball Hall of Famer Jim Bunning was the 89er field manager in 1976 and led the 89ers to a second place finish in the four-team Western Division of the American Association. He managed a team that was filled with future major leaguers—Lonnie Smith, Randy Lerch, John Montague, Bill Nahorodny, Wayne Nordhagen, Willie Hernandez, Dane Iorg, Bob Oliver, and Jim Morrison. Bunning was the first pitcher in the big leagues since Cy Young to win more than 100 games and strike out more than 1,000 batters in each league. When he retired, he was second in career strikeouts to Walter Johnson. He led the league in strikeouts in 1959, 1960, and 1967. He was 224-184 lifetime, winning 20 games only once, in 1957 for the Tigers. After baseball, Bunning served as a congressman and United States Senator from Kentucky. (Oklahoma Publishing Company.)

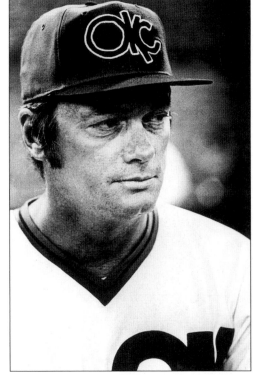

A future major leaguer who played for manager Jim Bunning's 1976 89ers was Dane Iorg, Oklahoma City's top hitter at .326. In the middle of the following season, he was batting .326 when he was traded to the Cardinals for Bake McBride. He was a college All-American at Brigham Young University. He hit .276 lifetime in ten years in the majors, saving his big games for championship series. He hit .500 in two League Championships and .526 in seven World Series contests in 1982 and 1985. He hit a two-run pinch single and won Game Six of the 1985 World Series for the Royals. He was normally a first baseman or outfielder but pitched in two games for the Padres in 1986. (Oklahoma Publishing Company.)

"Lightnin" Lonnie Smith was an Oklahoma City 89er in four different seasons beginning in 1976. His name appears several times in the 89er record book. He is tenth in single season batting average (.330) and second in runs scored in a season (106). He is the career leader with 171 stolen bases, third in doubles, and first in triples. Smith was *The Sporting News'* Rookie of the Year in 1980. Two years later he led the Cardinals to the world championship and led the club in hits, doubles, triples, average, runs, and stolen bases. He tied a National League record by stealing five bases in a game. He was an All-Star in 1982. Smith hit .285 lifetime in 17 seasons for the Phillies, Cardinals, Royals, Braves, Pirates, and Orioles. (Oklahoma Publishing Company.)

Midwest High School baseball star Ted Cox set a record that is still the best in 128 years of professional baseball. In 1977, he hit safely in his first six at-bats, a record that may never be broken. He climbed the minor league ladder in the Red Sox system and was the 1977 Topps Minor League Player of the Year and International League Player of the Year when he hit .335 for Pawtucket. He was called up to Boston in September and appeared as the designated hitter on September 18 on a day the stadium was filled to capacity to honor Brooks Robinson. Cox singled in the first and the public address announcer informed the Fenway Park crowd it was his first major league at-bat. Over the next two games, Cox established his six-for-six record and hit .362 in the final 13 games of the season. He was bothered by foot problems in his brief major league career. After baseball, he volunteered for the Oklahoma Sports Museum in Guthrie and was active in youth baseball in Midwest City. (Oklahoma Historical Society.)

A member of the 1976 89er pitcher staff was Willie Hernandez, who later won the Cy Young Award and was American League Most Valuable Player in 1984 when he was 9-3 and saved 32 games in 33 chances with a blistering 1.92 ERA. He pitched for 13 seasons in the big leagues. His 0.96 ERA in six World Series games is among the best in history. Fans always called Hernandez "Willie" although he preferred his given name of Guillermo. He was named to the American League All-Star team from 1984 to 1986. (Baseball Hall of Fame Library.)

Keith Moreland is a member of the Oklahoma City 89ers Hall of Fame. In 1979, he drove in 109 runs, batted .302, hit 34 doubles, and slugged 20 home runs. He hit .293 as an 89er. He made the American Association All-Star team in 1978 and 1979. In 12 seasons as a third baseman, catcher, and outfielder, he led the Cubs in batting in 1983 with a .302 average. Moreland's best major league campaign was 1985 when he hit .307 with 14 homers and 106 RBIs. (Oklahoma Publishing Company.)

Luis Aguayo was a slick-fielding shortstop for the 89ers in 1980 before he was called up to the majors by the Phillies. For five big league seasons he was a utility infielder. However, in 1985 he became a regular. Two years later, he hit 12 home runs in just 209 plate appearances and homered to eliminate the Mets from the 1987 pennant race. A native of Puerto Rico, Aguayo played ten major league seasons with the Phillies, Yankees, and Indians. He hit .236 lifetime. In the late 1990s, he managed Boston's Rookie League Gulf Coast Red Sox. (Oklahoma Publishing Company.)

"Bleacher Creature" was the 1980 89er mascot at All Sports Stadium. In this photograph, Rolanda Lee, a 12-year-old fan from Del City, gets a hug from the creature during a birthday party at the stadium. Bing and Patty Hampton were persistent in using mascots and other advertising programs to promote baseball in Oklahoma City. (Oklahoma Publishing Company.)

The all-time single season batting champion for Triple A players in Oklahoma City is Cuban-born Orlando Gonzalez who hit .354 in 1980. "Big O" started out hitting well and stayed hot, with a 29-game hitting streak. Fans were delighted, but disappointed, when he dramatically announced during a game in July that he had been sold to the Oakland A's and once again had a chance to make it in the big leagues. He had played sparingly in two previous seasons in the majors. However, Gonzalez could not stick with Oakland and retired from baseball. (Oklahoma Historical Society.)

Bob Walk won five of his first six decisions as an 89er in 1980 before he was promoted to the big league Phillies in May. Over the next 14 seasons, he pitched in 350 major league games for the Phillies, Braves, and Pirates. After arriving from Oklahoma City in 1980, Walk won 11 games and was the winning pitcher in Game One of the World Series. He was traded to the Braves the following year and spent the next 13 years bouncing back between the minors and the big leagues. He led the PCL in ERA in 1984 and 1985. (Oklahoma Publishing Company.)

83

Bob Dernier was an excellent base-stealing centerfielder for the 89ers in 1981 before being called up by the Phillies in the middle of the season. He played ten years in the major leagues for the Phillies and Cubs. As a leadoff hitter for the Phillies in 1982, he set a rookie record with 42 stolen bases. He appeared in one game in the 1983 World Series. He won the Gold Glove in 1984, the first Cubs outfielder to ever win the cherished prize. His 45 stolen bases that year were the most for a Cub in 77 years. (Oklahoma Publishing Company.)

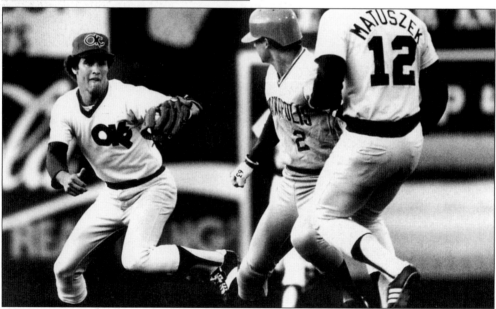

Ryne Sandberg played shortstop for the 89ers in 1981 after hitting .310 with 11 homers at Reading the previous season. Sandberg was the National League All-Star second baseman from 1984 to 1989. Sandberg is a member of the 89er Hall of Fame and was the National League Most Valuable Player in 1984. In his 14 major league seasons, he hit .289 with 245 home runs and 905 RBI's. He was the last of the "Chicago 89ers," one of several players in the Phillies organization that became Cubs when Dallas Green left Philadelphia to become general manager in Chicago, and began importing former 89er players. In this photograph, Sandberg (left) and Len Matuszek catch Indianapolis' German Barranca in an April 1981 rundown. (Oklahoma Publishing Company.)

84

One of the new marketing attractions at 89er games in 1981 was a contest to see which child could do the best job with a baseball coloring book. (Oklahoma Publishing Company.)

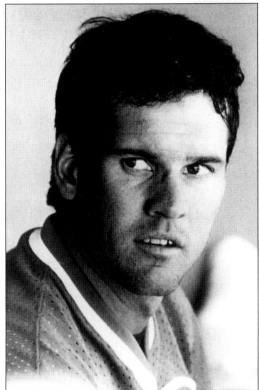

Former 89er Ryne Sandburg was one of the slickest fielding second basemen in the history of baseball. The ten-time all-star won nine Golden Gloves (1983-1991) with a career fielding percentage of .989 and an NL record of 123 consecutive errorless games at second base. He also batted .385 in post-season play, but even that could not help the Cubs reach the World Series. (Baseball Hall of Fame Library.)

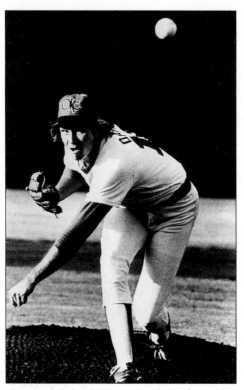

Philadelphia moved Mark Davis to Oklahoma City in 1981 after a 19-6 season in the Eastern League the year before. While pitching for the 89ers in 1981 and 1982, he was hampered by a sore shoulder, posting a 5-12 record for the 89ers in 1982. However, Philadelphia club officials recognized his potential and promoted him to the majors. Seven years later, Davis won the Cy Young Award as a San Diego Padre, a year in which he was overpowering with 44 saves and a 1.85 ERA. He struck out more than one batter per inning that season. In this photograph, Davis lets fly a curveball during a 1981 appearance against Denver at All Sports Stadium. (Oklahoma Publishing Company.)

Joe Carter was born in Oklahoma City, the eighth of 11 children. After graduating from Millwood High School and being named College Player of the Year while playing at Wichita State University, he was the Cubs' top draft choice in 1981. He had to sell his cowboy boots to help feed his family while he waited on a check for his signing bonus. He played briefly with the Cubs before he was traded to Cleveland. Carter was a superstar, hitting 396 career home runs. He retired after the 1998 season but went out in style. He hit .300 with several game-winning hits for the Giants in September. No baseball fan will ever forget Carter's home run in the bottom of the ninth inning to end the 1993 World Series, giving Toronto a second successive world championship. (Oklahoma Publishing Company.)

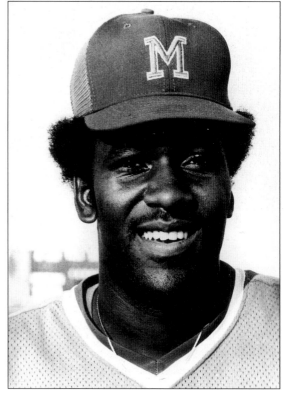

Darrell Porter, a product of Oklahoma City's Southeast High School, was the Most Valuable Player of the 1982 World Series. As a Cardinal, he dominated the post season that year by hitting .556 in the LCS and made key hits in the World Series win over the Brewers. He was a catcher with a strong arm and knack for handling pitchers. In 1979, he led the league with 121 walks and hit .291 with 20 homers. He was only the second catcher in history to top 100 in runs scored, RBIs, and walks in a single season. He was an All-Star in 1974 and 1978-1980. He played 17 seasons with the Brewers, Royals, Cardinals, and Rangers, hitting 188 career home runs. (Oklahoma Publishing Company.)

A star shortstop for the 89ers in 1982, Julio Franco hit .300 with 21 home runs and 19 doubles. The performance won him a spot with the parent Phillies, the beginning of an outstanding major league career with the Phillies, Indians, and Rangers. He was one of the best offensive middle infielders of the 1980s. He had 90 RBIs in 1985 and batted .303 or better from 1986 to 1988. When traded to the Texas Rangers in 1989, he became a team leader. In his first season with Texas he drove in 92 runs and batted .316. Franco was an American League All-Star in 1989 and 1990. He later succeeded as a designated hitter for the Indians and Brewers. In 2002, at age 44, he played in 125 games for the Atlanta Braves in his 18th major league season. (Oklahoma Publishing Company.)

Bake McBride (left) played for Oklahoma City in 1983 after 11 seasons in the major leagues with the Cardinals, Athletics, and Indians. He hit .299 lifetime with 183 career stolen bases. He hit over .300 in seven of his 11 seasons. He was the National League Rookie of the Year in 1974 and made the All-Star team in 1976. In 1978, he let senior circuit outfielders in fielding and tied a major league record with 10 chances in a single game. In this photograph, McBride is greeted by teammate Pete Rose after McBride slugged a three-run homer for the Phillies in Game One of the 1980 World Series. (Baseball Hall of Fame Library.)

Jose Guzman pitched a shutout against Omaha for the 89ers in June of 1985. At mid-season, he was called up to the big leagues by the Texas Rangers and began an eight-year stint in the majors. He had an 80-74 lifetime record with a 4.05 ERA. Guzman's best year was 1992 when he posted a 16-11 record with a 3.66 ERA for the Rangers. He also played briefly for the Cubs. (Oklahoma Publishing Company.)

Former University of Oklahoma outfielder Joe Simpson was the color commentator for 89er games in 1985. He is a native of Purcell, Oklahoma, and was an All-American at OU. Simpson was the Dodgers' third-round draft choice in 1973 and made it to the Los Angeles roster in 1975. He played 607 major league games over nine seasons for the Dodgers, Mariners, and Royals. In 1992, he became the color analyst for Atlanta Braves' broadcast on WTBS. (Oklahoma Publishing Company.)

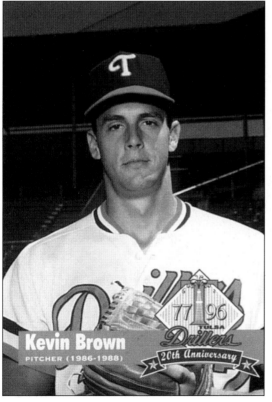

Kevin Brown was the first pitcher in baseball history to sign a $100 million contract. On his way to the majors, he pitched at Tulsa and Oklahoma City where he was 0-5 in 1987. Fortunately, the Rangers recognized his talent and promoted him in 1989 for a full season in the majors. In 1992, he won 21 games for Texas. After pitching for the Rangers, Orioles, Marlins, and Padres, Brown became a Los Angeles Dodger in 2002. In this photograph Brown is shown as a member of the 1988 Tulsa Drillers team that won the Texas League championship. He was third in the 1998 National League Cy Young balloting. (Tulsa Drillers.)

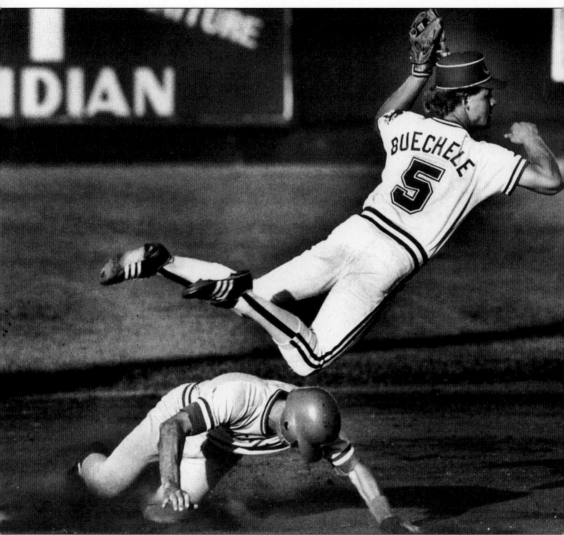

Oklahoma City 89ers second baseman Steve Buechele goes flying through the air to avoid a sliding Wichita player in 1985. Buechele was the starting third baseman before Texas promoted him to the majors later than year. When Buddy Bell was traded, Buechele became the Rangers' regular third baseman. He roomed at Stanford University with John Elway and played 11 major league seasons for the Rangers, Pirates, and Cubs. He hit .245 lifetime with 69 career homers. He batted .304 in seven games of the 1991 LCS. (Oklahoma Publishing Company.)

A star pitcher for the University of Oklahoma, Bobby Witt made his major league debut with the Rangers in 1986 after pitching only 35 innings in the minors. In his first two seasons, he led the American League in both walks and strikeouts. In 1988, after starting the season 0-5, he was sent to the 89ers. He returned to the big leagues on July 7 and was a different pitcher. He completed his first nine starts and walked only 66 batters in 138 innings. (Oklahoma Publishing Company.)

Toby Harrah was hired as field manager for the 89ers in 1987 after a great 17-year career in the major leagues. In two seasons at the helm of the 89ers, he posted a 138-145 record with two fourth place finishes. Harrah played in 2,155 major league games for the Senators, Rangers, Indians, and Yankees. He hit more than 20 home runs in five seasons. In 1976, he led American league shortstops in chances and putouts. He holds two odd baseball records—in 1976 he had no chances in a doubleheader and no assists in a 17-inning game at third base. (Oklahoma Publishing Company.)

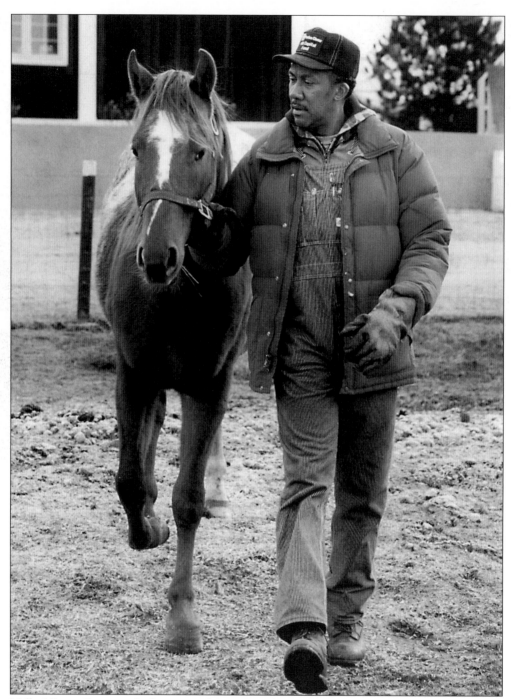

Hall of Famer Ferguson Jenkins moved from Canada to Oklahoma City in 1988 to become the 89ers pitching coach. He fell in love with the countryside and established a horse ranch near Guthrie, north of Oklahoma City. Jenkins, the only 89er and Canadian in the Baseball Hall of Fame, settled on his Guthrie ranch after coaching for the Rangers, Reds, and Cubs. He is the winningest African-American pitcher in the history of major league baseball.(Oklahoma Publishing Company.)

From left to right, Abner 89er (the club mascot), Sam Burdick, Ferguson Jenkins, and Stan Hupfeld admire an 89er bat before a game at All Sports Stadium in 1988. Jenkins was the 89er pitching coach after completing a Hall of Fame career in which he won 284 games and pitched 4,500 innings. He won 20 games in six consecutive seasons and pitched more than 300 innings five times. He set a modern Cub record with 236 strikeouts in 1967 and then topped his own record the next three seasons. He equaled Carl Hubbell's record of six strikeouts in an All-Star game by fanning six batters in three innings in 1967. Jenkins had one of the best seasons in modern baseball history in 1971 when he became the first Cub pitcher to win the National League Cy Young Award. He had a 2.77 ERA and led the senior circuit with a 24 wins, 30 complete games, and 325 innings. He also helped his own cause by hitting .243 with six home runs. After a few seasons with Texas, Jenkins returned to the Cubs where he finished out his career in 1982. He is the only pitcher in history with more than 3000 career strikeouts and fewer than 1000 walks. (Oklahoma Publishing Company.)

All Sports Stadium was the scene of many college baseball games, including the Big Eight Baseball Tournament. In this photograph, Oklahoma State University and future major league star Robin Ventura runs toward first base in a 1988 game against the University of Oklahoma. Ventura was named the outstanding amateur baseball player in the country in 1988. In the majors, he became a perennial winner of the Gold Glove Award at third base. (Oklahoma Publishing Company.)

Samma Sosa played for both Tulsa and Oklahoma City on his way to a sparkling major league career, highlighted by his 1998 race against Mark McGwire to top Roger Maris' single season home run mark. Sosa played part of the 1989 season for Oklahoma City before being traded to the Chicago White Sox by the Rangers. In 1992, he was traded to the Cubs where he became one of the biggest stars in the game. From the Dominican Republic, Sosa was the 1998 National League Most Valuable Player for his part in taking the Cubs to the playoffs. During the 1998 home run race, Sosa set a major league record of most home runs in a month. He hit 20 round-trippers in June of 1998. (Oklahoma Publishing Company.)

Juan Gonzalez was 20 when he played centerfield for the 89ers in 1990 and led the American Association with 29 home runs and 101 RBIs. His performance gained him honors as American Association Rookie of the Year and Player of the Year. When Gonzalez was promoted to the big league Texas Rangers, he became a slugging star. He is the leading home run hitter and run-producer in Rangers' history. He batted .314 with 47 homers in 1996 and was named the American League Most Valuable Player, an honor he again won two years later. For much of the 1998 season, it appeared that Gonzalez might break one of the oldest records in baseball, Hack Wilson's single-season RBI record. Gonzalez fell short, but let the American League with 157 RBIs. Gonzalez began his 15th big season in 2003. (Oklahoma Publishing Company.)

Dean Palmer was the greatest home run hitter in Oklahoma City history, not in total homers, but in frequency. In just 60 games for the 89ers in 1991 before being called up to the Rangers, he hit 22 home runs. He stuck in the majors after his phenomenal home run output and .299 average for the first half of the 1991 season. In 1996, Palmer set a major league record for fewest assists and chances by a third baseman. In 1998, he was Kansas City's leading power hitter with 34 home runs and 119 RBIs. In 1999, he was traded to Detroit. (Oklahoma Publishing Company.)

The 1990 Oklahoma City 89ers. At far right on the first row is future major league star Juan Gonzalez. (Oklahoma Publishing Company.)

At first base and as a designated hitter, Steve Balboni twice led the American Association in home runs. His personal best was 36 round-trippers in 1993, the second best season total in Oklahoma City Triple A history. In three seasons with the 89ers, Balboni hit 86 home runs and drove in 275 runs. He made the American Association All-Star team in 1992 and 1993. He was a major reason for the 89ers winning the pennant in 1992. He was a streak hitter in 13 years in the majors, before playing for the 89ers. (Oklahoma Publishing Company.)

Sporting her new 89ers cap, fan Jessica Oxford of Edmond tries to get a few autographs at a game at All Sports Stadium in August of 1991. (Oklahoma Publishing Company.)

In 1992, the 89ers, as a fan promotion, dressed up in vintage Oklahoma City Indian uniforms. Fans were invited to wear 1930s clothing to the game. Pictured, from left to right, are Dan Peltier, Bill Haselman, and Russ McGinnis. (Brad Tammen and Oklahoma RedHawks.)

89ers president, Clay Bennett (left), and major league superstar Nolan Ryan are seen just before Ryan threw out the first pitch at an 89er game. (Oklahoma Redhawks.)

What a difference a few years made in the appearance of the Diamond Dolls, the popular "cheerleaders" for the 89ers. In this photograph, the Dolls are dressed in traditional cheerleader uniforms in the early 1980s. The Dolls appeared at games and charity events to publicize the 89ers. (Oklahoma RedHawks.)

The Diamond Dolls became the Diamond Girls in 1992, with flashier costumes. In this photograph, they held bats rather than pom-poms as their predecessors had done in the past. (Oklahoma RedHawks.)

Bob Hersom, a sportswriter for *The Daily Oklahoman*, has written much about Oklahoma baseball in recent decades, since arriving in Oklahoma City in 1980. He has covered professional baseball for 30 years, including his days at his hometown newspaper, *The Cedar Rapids* (Iowa) *Gazette*. In a story about the best and worst teams in minor league history in the Sooner State, he called the 1937 Oklahoma City Indians the best AA (called Class A-1 at the time) team in state history. That year, led by pitcher Ash Hillin with 31 wins, the Indians finished 101-58 and won the Texas League by 11 games before losing the league championship series to Fort Worth. Hersom also designated the 1965 Oklahoma City 89ers as one of the two top Triple A clubs. Grady Hatton's 89ers won the Pacific Coast League East by eight games then beat Portland in the championship series. In the worst category, Hersom called the 1956 Oklahoma City Indians (48-106) and the 1982 89ers (43-91) the worst AA and Triple A clubs. (Oklahoma Publishing Company.)

Rick Reed pitched sparingly for the 89ers in 1993 and 1994. He had begun his big league career in 1988 with the Pirates but was sent to the 89ers by Texas in 1993. He was the American Association Most Valuable Player in 1991 playing for Buffalo. His best year in the majors was 1998 when he started 31 games for the Mets and posted a 16-11 record with a 3.48 ERA. His 1.23 walks per nine innings was second best in the National League. He was traded to the Twins in 2001. (Oklahoma Publishing Company.)

Lee Stevens batted .325 and led the American Association with 32 home runs and 94 RBIs for the 89ers in 1996. His numbers won him the American Association Most Valuable Player Award. He began his big league career with the Angels in 1990 and played in Japan in 1994 and 1995 before being signed by the Rangers. After his solid year in 1996, Stevens made it to the major leagues to stay. In 2000, the Rangers traded him to Montreal where he was the regular first baseman. In 2002, he became a Cleveland Indian in his tenth major league campaign. (Oklahoma Publishing Company.)

Choctaw's Gary Haught made it to the major leagues as a right-handed pitcher in 1997 after spending several years in the Oakland A's farm system. (Oklahoma Publishing Company.)

A.J. Hinch, a graduate of Midwest City High School, played on the 1996 U.S. Olympic baseball team before being signed by the Oakland A's. His major league debut season was 1998 when he played behind the plate in 120 games. In 2001, he was traded to Kansas City. In 2002, he caught 72 games and batted .249 with seven home runs. (Oklahoma Publishing Company.)

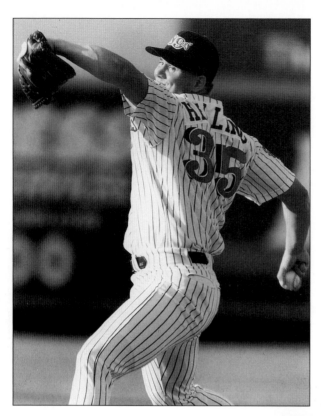

Rick Helling pitched a perfect game for the 89ers on August 13, 1996. His cap and the official score sheet from the game are on display at the Baseball Hall of Fame. The nine-inning perfect game was the first and only of its kind in Oklahoma City minor league history. After his years with the 89ers, Helling moved on to the big leagues with the Rangers and established himself as a premier major league hurler. He won 20 games in 1998 and 16 games in 2000. He was traded to the Arizona Diamondbacks in 2002. (Oklahoma Publishing Company.)

Broadcaster Curt Gowdy returned to his broadcast roots to serve as master of ceremonies at the 89ers' last game at All Sports Stadium in 1997. (Richard Clifton and Oklahoma Sports Museum.)

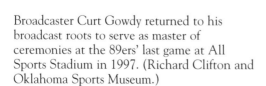

FOUR

A New Era

The RedHawks

Oklahoma City had a new team with a new name and a new ballpark in 1998. As part of a major Oklahoma City downtown redevelopment program, the Southwestern Bell Bricktown Ballpark was completed in 1998. The previous year, General Manager David Vance announced that Oklahoma City's entry in Triple A would be known as the Oklahoma RedHawks, named after the fierce, proud Red-Tailed Hawk, indigenous to the state. It was the first time in history that "Oklahoma City" was not used in the team name. Vance cited research that showed Oklahoma City teams had become much more statewide teams, with tremendous support throughout Oklahoma.

In 1998, Clay Bennett was president of the investment group that hired Tim O'Toole as general manager and launched the RedHawks' inaugural season as a member of the American Conference of the Pacific Coast League. O'Toole had vast experience running a sports organization. He was director of operations of the 1989 U.S. Olympic Festival in Oklahoma City ran the national headquarters of the American Softball Association/USA Softball for six years.

The RedHawks finished the 1998 season at 74-70, good enough for second place in the Eastern Division. Warren Newson had a 22-game hitting streak, second only in four decades of Triple A baseball in Oklahoma City to Orlando Gonzalez's 29-game streak in 1980. The all-time Oklahoma City record is Milt Nielsen's 32-game hitting streak in 1949. In the new stadium, average attendance was more than 7,000, twice the average in the previous season at All Sports Stadium.

In the RedHawks' second season, manager Greg Biagini led the team to a first-place finish in the PCL's Eastern Division of the American Conference. Oklahoma won the first round of the playoffs against Omaha but fell to Vancouver in the PCL championship. In 1999, Oklahoma's pitching staff led the PCL in complete games with 16.

DeMarlo Hale became field manager in 2000 and was at the helm as the RedHawks finished second in their division the next two seasons. In 2002, under manager Bobby Jones, the club topped the Eastern Division of the PCL but lost the American Conference championship to Salt Lake City.

Fan support has been strong for Oklahoma. In the first six RedHawk seasons, attendance at opening night games averaged nearly 9,000. In 2003, team owner, Gaylord Entertainment, was interested in selling the team. However, most observers agreed that the future of Triple A baseball in Oklahoma City is bright.

Year	Team	Finish	W	L	League	Manager	Affiliate
1998	RedHawks	2 of 4	74	70	PCL	Biagini	Texas
1999	RedHawks	1 of 1	83	59	PCL	Biagini	Texas
2000	RedHawks	2 of 4	69	74	PCL	Hale	Texas
2001	RedHawks	2 of 4	74	69	PCL	Hale	Texas
2002	RedHawks	1 of 4	75	69	PCL	Jones	Texas
2003	RedHawks				PCL	Jones	Texas

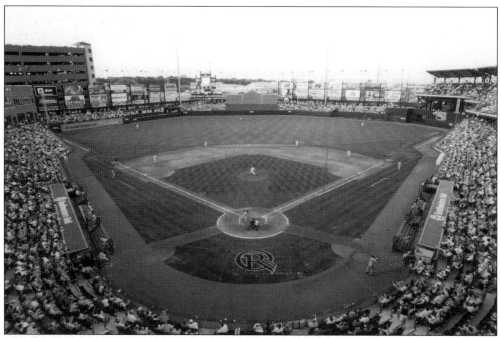

The Southwestern Bell Bricktown Ballpark (later renamed SBC Bricktown Ballpark), opened to huge crowds on April 16, 1998. More than 14,000 fans jammed the park to unveil a new era in Oklahoma City baseball. The open-air park is a state-of-the-art facility that is fan friendly. Seating is close to the field—every seat is a good seat, reminiscent of many of the nation's older ballparks. The park is located on Mickey Mantle Drive, named after Oklahoma's most famous baseball hero, in the Bricktown Area, a renewed warehouse district just east of downtown Oklahoma City. (Oklahoma RedHawks.)

Thousands of fans waited outside the Third Base gate of the Bricktown Ballpark on opening day, April 16, 1998. The new 13,066-seat facility, quickly nicknamed "The Brick" was one of the cornerstones of Metropolitan Area Projects (MAPS) redevelopment program for downtown Oklahoma City. Voters approved a long-term sales tax to pay for the ballpark and other projects to revitalize the area. The park was designed by Architectural Design Group, Inc. of Oklahoma City. (Oklahoma RedHawks.)

Outside the Third Base gate at the Bricktown Ballpark stands the statute of Mickey Mantle, alongside Mickey Mantle Drive. The nine-foot statue, sculpted by Blair Buswell, honors one of baseball's true superstars. (Oklahoma RedHawks.)

Mickey Mantle's family attended the April 16, 1998 dedication of the statue of Mantle at Bricktown Ballpark. From left to right are David Mantle, Merlyn Mantle, Charles Mantle, and Lisa Mantle. (Oklahoma RedHawks.)

Many former New York Yankee players appeared at The Brick for the dedication of the Mickey Mantle statue. ESPN's Roy Firestone (right) was the master of ceremonies for the event. In this photograph, he poses with former Yankee greats and Mantle teammates Bobby Richardson (left) and Yogi Berra. (Oklahoma RedHawks.)

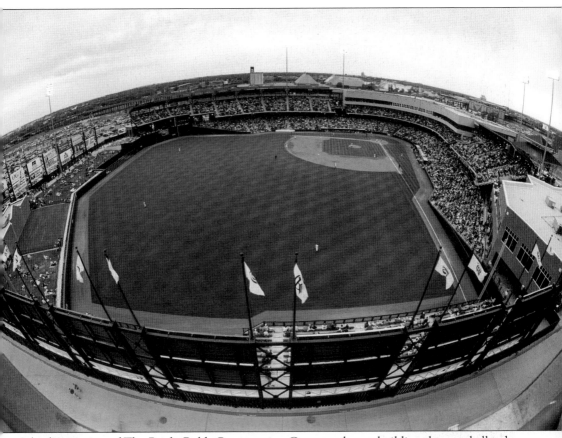

A bird's eye view of The Brick. Boldt Construction Company began building the new ballpark in 1996 and completed it in time for the April 16, 1998 opening. The openness of the park is incredible. There is a clear view of the field from the concourse. Fans can walk all the way around the park inside the fence. A picnic seating area is located on the grassy berm behind the outfield fence. The park soon was recognized as one of the outstanding minor league facilities in the country. (Oklahoma RedHawks.)

Greg Biagini was field manager for the RedHawks in their first two seasons. He came to the 89ers as manager in 1995, won the American Association pennant the following year, and was named league manager of the year. Biagini was a minor league manager in the Orioles' farm system for nine years and was Baltimore's hitting coach for three seasons before becoming manager of the 89ers. In 1990, he was Eastern League manager of the year at Rochester. After leaving Oklahoma City, he was hired as the Orioles' roving minor league hitting instructor. (Oklahoma RedHawks.)

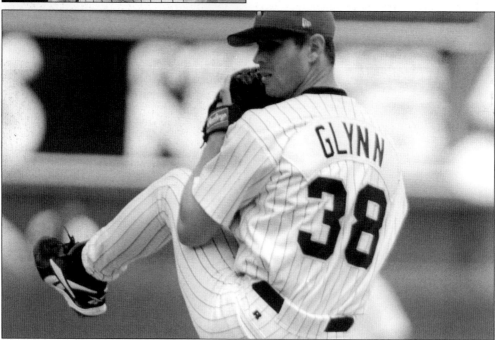

Ryan Glynn pitched 8 1/3 innings of no-hit ball against New Orleans on April 28, 1999, at The Brick. A one out single broke up the no-hitter but Glynn beat the Zephyrs with his one-hit performance. He was 6-2 with a 3.39 ERA for the RedHawks in 1999 and started the opening games of both playoff series. He won Game One of the first-round series against Omaha. During the 1999 season, Glynn was called up to the parent Texas Rangers three times, staring ten games and going 2-4 with a 7.24 ERA. (Jeff Marks and Oklahoma RedHawks.)

Oklahoma City Mayor Kirk Humphreys (left) poses with Rowdy RedHawk, the Oklahoma team mascot. (Oklahoma RedHawks.)

A young RedHawk fan models the RedHawk uniform containing the unique and modern RedHawk emblem and pinstripe pants. (Oklahoma RedHawks.)

First baseman Andy Barkett led the team with 149 hits in 1999 and batted .307 in 132 games. The year before, the batted .314 in 80 games after being promoted from Tulsa. In 1999, he led the team in hits with 149 and was tops in the PCL among first basemen in fielding. He committed on six errors in 1,096 chances. He hit one of the RedHawks' two grand slams in 1999. (Oklahoma RedHawks.)

Jack Damrill was the play-by-play announcer for 89er and RedHawk radio broadcasts on WKY-Radio in Oklahoma City from 1995 to 1998. (Oklahoma RedHawks.)

In 1999, Jim Byers became the radio voice of the RedHawks. He broadcast the games on WKY-Radio through the 2002 season. (Oklahoma RedHawks.)

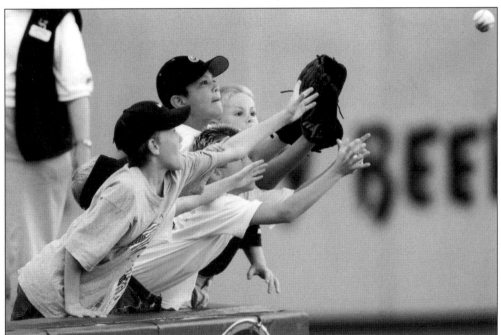

Young RedHawk fans clamor for a foul ball at The Brick. One of the great features of the ballpark is its closeness to the playing field. (Oklahoma RedHawks.)

Shortstop Scott Sheldon was named to the PCL Post-Season All-Star Team and *Baseball America*'s Post-Season Triple-A All-Star team in 1999. He hit .311 for the '99 RedHawks in 122 games. He also slugged 28 homers and drove in 97 runs. (Oklahoma RedHawks.)

Kelly Dransfeldt batted .237 with Oklahoma in 1999 and was named the PCL's best defensive shortstop prospect by *Baseball America* in mid-season. He was the RedHawks regular shortstop the following season and hit .247 with eight homers and 42 RBIs. He was called up to the Rangers three times in the 2000 season. In 2001, he played in all 143 games for Oklahoma and hit .250 with nine home runs and 63 RBIs. He was out of the 2001 lineup for only seven innings all season. He is the RedHawks' all-time leader in games, hits, doubles, and strikeouts. (Oklahoma RedHawks.)

Ruben Mateo hit .336 in 63 games for the RedHawks in 1999. He also hit 18 round-trippers with 62 RBIs. He was named as an outfielder on *Baseball America*'s Post-Season Triple-A All-Star team. Mateo spent all of 2000 and part of the 2001 season with the Rangers before being sent to Oklahoma where he played in 14 games. In 2002, he became a Cincinnati Red and batted .256 in 46 games. (Oklahoma RedHawks.)

Greg Harrel became the team trainer in 1992. A graduate of the University of Central Oklahoma, he was the Tulsa Drillers' trainer for five years before joining the 89ers and the RedHawks. In 2002, he was promoted to assistant trainer for the Texas Rangers. (Oklahoma RedHawks.)

Mike Zywica was a RedHawks outfielder in 1999 and 2000. He hit .252 for Oklahoma in 2000 when he spent all but one week of the season with the RedHawks. In 1999, he hit in every spot in the order except fifth. He batted .359 in August of that season and drove in a club-high 28 runs. In 1998, he led the Arizona Fall League in hitting with a .330 average. (Oklahoma RedHawks.)

Matt Perisho was named the starting left-handed pitcher on *Baseball America*'s 1999 Post-Season Triple-A All-Star team. He was 15-7 in the regular season with a 4.61 ERA and 150 strikeouts. He was 8-5 for the RedHawks in 1998. After appearing in 34 games with a 2-7 record for Texas in 2000, he was traded to the Tigers. (Oklahoma RedHawks.)

Oklahoma City native Johnny Bench (right) stands in front of his statue unveiled in 2001 at The Brick. Standing beside him is RedHawks General Manager Tim O'Toole. Many consider Bench the greatest catcher of all time. In 1989, he became one of the youngest players ever inducted in the Baseball Hall of Fame. He was National League Rookie of the Year in 1968, the first catcher to win that award. He had great seasons for the Big Red Machine at Cincinnati. In the decade of the 1970s, he drove in more runs, 1,013, than any other major league hitter. He was National League Most Valuable Player twice—in 1970, at age 22, he was the youngest player ever named MVP. He played his entire 17-year career for the Reds and selected for the All-Star team 13 consecutive years. Bench was the MVP of the 1976 World Series. (Oklahoma RedHawks.)

In 2000, DeMarlo Hale became manager for the RedHawks. From 1993 to 1999, he managed in the Boston Red Sox farm system. *The Sporting News* named him as minor league manager of the year in 1999 when he led Trenton to the Eastern League title. He spent six years playing minor league baseball in the Boston and Oakland systems. (Oklahoma RedHawks.)

Pedro Valdes was Oklahoma's top hitter in 1999. He batted .327 in 110 games and hit 21 home runs with 72 RBIs. In August, he hit six homers, drove in 20 runs, and batted .352. Valdes was originally selected by the Cubs in the 12th round of the 1990 draft. He appeared briefly in the majors for the Cubs in 1996 and 1998. (Oklahoma RedHawks.)

Ruben Sierra played for Oklahoma City on two occasions. He played the outfield for the 89ers in 1986 before making the jump to the big leagues with the Rangers. He returned to the RedHawks in 2000 and batted .326 in 112 games. He also hit 18 homers and drove in 82 runs. In 2001, Sierra played the first few weeks of the season at Oklahoma before the Rangers called him up where he appeared in 94 games and batted .291. He played outfield and was a designated hitter for Seattle in 2002, his 16th major league season. (Oklahoma RedHawks.)

Named the Texas Rangers minor league player of the year in 1999, Mike Lamb hit .324 at Tulsa before playing briefly with the RedHawks. He played third base for part of the 2001 and 2002 seasons at Oklahoma. In 2001, he was promoted to Texas on June 17 and hit .306 with four home runs and 35 RBIs the remainder of the season. In 2002, Lamb played only six games for Oklahoma and 115 games for the Rangers, hitting .283. (Oklahoma RedHawks.)

R.A. Dickey was promoted to the RedHawks from Tulsa on August 10, 1999, and won his first Triple-A start that night against Omaha. He finished the season 2-2. He was 8-9, 11-7, and 8-7 for Oklahoma in the 2000 to 2002 seasons. He had a respectable 3.75 ERA in 2001. He was a member of the bronze medal-winning U.S. Olympic baseball team in 1996. In 2002, he led the RedHawks in innings pitched and strikeouts for the third straight season. He began 2003 as the RedHawks' all-time leader in career strikeouts (33), innings (498), starts (68), wins (29), and losses (25.) (Oklahoma RedHawks.)

Doug Davis was the Texas Rangers minor league pitcher of the year in 1999 while playing for Tulsa and the RedHawks where he posted a combined 11-4 record with a 2.72 ERA. He was 1-0 in the 1999 PCL playoffs and pitched part of each of the 2000-2002 seasons for the RedHawks. Davis has played part of four seasons with the Rangers in the big leagues. He is 21-21 in the majors. (Oklahoma RedHawks.)

After two seasons as a coach for the Texas Rangers, Bobby Jones became field manager for the RedHawks in the 2002 season. He has been in the Rangers organization since 1981 in some capacity. He managed the Tulsa Drillers after spending nine years in the major leagues with Texas and California. He holds the Texas club record for career pinch hits (42). He played for the Oklahoma City 89ers in 1983 and 1986 and managed the 89ers in 1993 and 1994. He led the RedHawks to the PCL's American Conference East Division championship in 2002. (Oklahoma RedHawks.)

Jamey Wright returned to his hometown, Oklahoma City, to pitch for the RedHawks in the 2003 season. He graduated from suburban Westmoore High School and was picked in the first round of the 1993 draft by Colorado. He made it to the big leagues in 1996 with the Rockies. He also played for the Brewers and Cardinals before being traded to the Rangers in 2003. He led National League pitchers in hit batsmen in 2000 and 2001. Through the 2002 season, he was 50-67 in 174 big league appearances. (Oklahoma Publishing Company.)

Hank Blalock became the regular third baseman for the Texas Rangers in 2003 and led the major leagues in batting into June. His pitch-hit, eighth-inning home run lifted the American League to a 7-6 victory in the 2003 All-Star game in Chicago. A year earlier, Blalock had watched the All-Star game on television at his Oklahoma City apartment. He played 95 games for the RedHawks in 2002 and hit .307 with eight home runs and 62 RBIs. (Oklahoma RedHawks.)

The voice of the Chicago White Sox, John Rooney (right), receives the Bill Teegins Excellence in Sports Broadcasting Award in 2002 at the Oklahoma Sports Museum annual banquet in Guthrie. Presenting the award is Janis Teegins, the widow of Bill Teegins, who was killed along with nine others in the Oklahoma State University airplane crash in 2001. Teegins broadcast the first RedHawks game from the new Bricktown Ballpark in 1998. Oklahoma City has been a launching pad for baseball announcers making the jump from the minor leagues to the big leagues. From announcing Oklahoma City baseball, Curt Gowdy went to Boston and NBC, Bob Murphy went to the New York Mets, Larry Calton went to the Minnesota Twins, Brian Barnhart went to Anaheim, Joe Simpson went to the Braves, and Dewayne Staats went to the Cubs, Yankees, Astros, and Devil Rays. (Oklahoma Sports Museum.)

Aaron Myette was the starting pitcher for the 2002 Triple-A All-Star game played at The Brick. He was also named the Most Valuable Player of the game. In 2001, he was 4-3 in 12 starts with Oklahoma before being called up by Texas. In 2002, he was 7-4 with a 3.14 ERA through 16 games with the RedHawks before moving up to the Rangers where he was 2-5 in 15 appearances. (Oklahoma RedHawks.)

Diamond Girls entertain RedHawk fans by tossing tee-shirts into the stands. (Oklahoma RedHawks.)

Rowdy RedHawk cheers Oklahoma on to victory. (Oklahoma RedHawks.)

RedHawk first baseman Travis Hafner was near the top in several offensive categories in the PCL in 2002. His .342 average was third best in the league, his .463 on-base percentage was tops in the circuit, and his slugging percentage of .559 was fourth best in the league. He played in 110 games for Oklahoma in 2002 and hit 21 home runs and drove in 77 runs. The performance won him a trip to the big leagues with the Rangers for 23 games, although the call up of the RedHawks' most valuable player had a detrimental effect upon Oklahoma's chances in the PCL playoffs. During the 2002 season, the RedHawks used 58 different players as the door swung freely from Texas to Oklahoma City. (Oklahoma RedHawks.)

Chris Demetral led RedHawk hitters in the 1999 playoffs with a .393 average. He finished the season by hitting safely in his last 11 games, including the playoffs. In 1998, Demetral batted .299 in 57 games for Oklahoma. (Oklahoma RedHawks.)

Brian Sikorski was 10-9 for the RedHawks in 2000, placing him in the top ten list of pitchers in the PCL. He struck 99 batters in 140 innings. (Oklahoma RedHawks.)

David Garrett became the radio voice of the Oklahoma RedHawks in 2003. Mike Treps, former University of Oklahoma sports information director, joined Garrett, the former play-by-play announcer for the Dallas Cowboys of the National Football League, in the RedHawks' broadcast booth. (Oklahoma RedHawks.)

Year	Team	Finish	W	L	League	Manager	Affiliate
1904	Mets	3 of 4	45	49	Southwestern	Rodgers/Warner/Barnes	
1905	Mets	2 of 8	77	58	Western Assn.	Barnes/Risley	
1906	Mets	5 of 8	70	69	Western Assn.	Chinn	
1907	Mets	5 of 5	86	54	Western Assn.	McFarland	
1908	Mets	3 of 8	81	58	Western Assn.	McConnell	
1909	Indians	2 of 8	79	63	Texas	Kelsey/Andrews	
1910	Mets	7 of 8	63	74	Texas	Andrews/Downey	
1911	Indians	7 of 8	72	77	Texas	Garvin	
1912	Senators	7 of 8	15	33	Oklahoma State	Langley	
1914	Boosters	2 of 6	75	52	Western Assn.	Holliday/Maag	
1915	Senators	2 of 8	76	62	Western Assn.	Maag	
1916	Senators	4 of 8	63	77	Western Assn.	Maag	
1917	Boosters	6 of 8	72	80	Western Assn.	Murray	
1918	Indians	6 of 8	33	37	Western	Holland	
1919	Indians	5 of 8	69	69	Western	Holland	
1920	Indians	3 of 8	82	68	Western	Humphries/Moell/Breen	
1921	Indians	3 of 8	93	75	Western	Breen	
1922	Indians	6 of 8	73	94	Western	Fisher/Egan	
1923	Indians	1 of 8	102	64	Western	Luderus	
1924	Indians	5 of 8	82	86	Western	Luderus	
1925	Indians	3 of 8	88	76	Western	Pettigrew/Luderus	
1926	Indians	2 of 8	100	66	Western	Luderus	
1927	Indians	5 of 8	68	86	Western	Luderus	
1928	Indians	1 of 8	95	67	Western	Gregory	
1929	Indians	2 of 8	88	68	Western	Leifield	
1930	Indians	3 of 8	79	71	Western	Kelly/Brower/Pettigrew	
1931	Indians	5 of 8	70	80	Western	Dixon/Tobin	
1932	Indians	3 of 8	83	67	Western	Luderus	
1933	Indians	8 of 8	62	90	Texas	Luderus/Harvel	
1934	Indians	8 of 8	59	93	Texas	Harvel	
1935	Indians	1 of 8	95	66	Texas	Niehoff	
1936	Indians	4 of 8	79	75	Texas	Niehoff	
1937	Indians	1 of 8	101	58	Texas	Keesey	
1938	Indians	3 of 8	89	70	Texas	Keesey/Fitzpatrick	
1939	Indians	7 of 8	59	102	Texas	Hass/Moore	
1940	Indians	4 of 8	82	78	Texas	Keesey/Hornsby	
1941	Indians	6 of 8	69	85	Texas	Hornsby/Peel	Cleveland
1942	Indians	7 of 8	69	85	Texas	Peel/Payton Kroner/Touchstone	New York
1946	Indians	8 of 8	54	98	Texas	Schalk	Cleveland
1947	Indians	6 of 8	71	83	Texas	Schalk/Ankenman	Cleveland
1948	Indians	6 of 8	70	84	Texas	Ankenman	Cleveland
1949	Indians	3 of 8	81	72	Texas	Vosmik	Cleveland
1950	Indians	6 of 8	72	79	Texas	Vosmik/Gowdy/Reis	Cleveland
1951	Indians	6 of 8	75	86	Texas	Tatum	
1952	Indians	4 of 8	82	79	Texas	Tatum	
1953	Indians	4 of 8	80	74	Texas	Tatum	
1954	Indians	3 of 8	87	74	Texas	Tatum	

Year	Team	Finish	W	L	League	Manager	Affiliate
1955	Indians	7 of 8	70	90	Texas	Tatum/Laskowski	
1956	Indians	8 of 8	48	106	Texas	Laskowski/Cash/Beeler	Boston
1957	Indians	7 of 8	66	86	Texas	Robinson	Boston
1962	89ers	5 of 6	66	81	American Assn.	Ryan	Houston
1963	89ers	1 of 5	84	74	PCL	Hatton	Houston
1964	89ers	3 of 6	88	70	PCL	Hatton	Houston
1965	89ers	1 of 6	91	54	PCL	Hatton	Houston
1966	89ers	6 of 6	59	89	PCL	McGaha	Houston
1967	89ers	4 of 6	74	74	PCL	McGaha	Houston
1968	89ers	6 of 6	61	84	PCL	Deal	Houston
1969	89ers	5 of 6	62	78	American Assn.	Deal	Houston
1970	89ers	3 of 4	68	71	American Assn.	Kittle	Houston
1971	89ers	2 of 4	71	69	American Assn.	Williams	Houston
1972	89ers	4 of 4	57	83	American Assn.	Pachecho	Houston
1973	89ers	3 of 4	61	74	American Assn.	Lucchesi	Cleveland
1974	89ers	3 of 4	62	74	American Assn.	Davis	Cleveland
1975	89ers	4 of 4	50	86	American Assn.	Davis	Cleveland
1976	89ers	2 of 4	72	63	American Assn.	Bunning	Philadelphia
1977	89ers	3 of 4	70	66	American Assn.	Ermer/Ryan/Connors	Philadelphia
1978	89ers	3 of 4	62	74	American Assn.	Ryan	Philadelphia
1979	89ers	1 of 4	72	63	American Assn.	Elia	Philadelphia
1980	89ers	2 of 4	70	65	American Assn.	Snyder	Philadelphia
1981	89ers	3 of 4	69	67	American Assn.	Snyder	Philadelphia
1982	89ers	4 of 4	43	91	American Assn.	Clark/Deal/Taylor	Philadelphia
1983	89ers	2 of 4	66	69	American Assn.	Burgess	Texas
1984	89ers	7 of 8	70	84	American Assn.	Burgess/Gerhardt	Texas
1985	89ers	1 of 4	79	63	American Assn.	Oliver	Texas
1986	89ers	4 of 4	63	79	American Assn.	Oliver	Texas
1987	89ers	4 of 8	69	71	American Assn.	Harrah	Texas
1988	89ers	4 of 4	67	74	American Assn.	Harrah	Texas
1989	89ers	4 of 4	59	86	American Assn.	Skaaleen	Texas
1990	89ers	4 of 4	58	87	American Assn.	Smith	Texas
1991	89ers	4 of 4	52	92	American Assn.	Thompson	Texas
1992	89ers	1 of 4	74	70	American Assn.	Thompson	Texas
1993	89ers	4 of 4	54	90	American Assn.	Jones	Texas
1994	89ers	7 of 8	61	83	American Assn.	Jones	Texas
1995	89ers	8 of 8	54	79	American Assn.	Biagini	Texas
1996	89ers	2 of 4	74	70	American Assn.	Biagini	Texas
1997	89ers	3 of 4	61	82	American Assn.	Biagini	Texas
1998	RedHawks	2 of 4	74	70	PCL	Biagini	Texas
1999	RedHawks	1 of 1	83	59	PCL	Biagini	Texas
2000	RedHawks	2 of 4	69	74	PCL	Hale	Texas
2001	RedHawks	2 of 4	74	69	PCL	Hale	Texas
2002	RedHawks	1 of 4	75	69	PCL	Jones	Texas
2003	RedHawks				PCL	Jones	Texas

All-Time Records

BATTING

Batting Average	.371, Albie Pearson, 1956
Home Runs	39, Jim Lemon, 1950
Runs Batted In	141, Al Rosen, 1947
Runs	139, Milt Nielsen, 1949
Hits	214, Herb Conyers, 1949
Doubles	41, Rob Maurer, 1991, and John Marzano, 1995
Triples	18, Bob Brower, 1985
Stolen Bases	72, Bob Dernier, 1981
Total Bases	283, Dan Walton, 1969
Bases on Balls	117, James McDaniel, 1962

PITCHING

Earned Run Average	1.06, Ray Fagan, 1915
Wins	31, Ash Hillin, 1937
Winning Pct.	1.000, 13–0, Ray Fagan, 1915
Strikeouts	245, Harley Young, 1911
Losses	17, Dan Smith, 1991
Saves	18, Allen McDill, 1999
Innings Pitched	207, Randy Lerch, 1976
Walks	116, Robert Watkins, 1969
Complete Games	13, Jim Kern, 1974, and Lowell Palmer, 1973

Triple A Records (1962–2002)

BATTING

Batting Average	.354, Orlando Gonzalez, 1980
Home Runs	38, Dave Roberts, 1965
Runs Batted In	119, Dan Walton, 1969

Runs	130, Bob Brower, 1986
Hits	193, Sonny Jackson, 1965
Doubles	41, Rob Maurer, 1991, and John Marzano, 1995
Triples	18, Bob Brower, 1985
Stolen Bases	72, Bob Dernier, 1981
Total Bases	283, Dan Walton, 1969
Bases on Balls	117, James McDaniel, 1962

PITCHING

Earned Run Average	2.45, J.R. Richard, 1971
Wins	19–8, Howie Reed, 1967
Winning Pct.	.923, Gary Beare, 12–1, 1979
Strikeouts	220, Jim Kern, 1974
Losses	17, Dan Smith, 1991
Saves	18, Allen McDill, 1999
Innings Pitched	207, Randy Lerch, 1976
Walks	116, Robert Watkins, 1969
Complete Games	13, Jim Kern, 1974, and Lowell Palmer, 1973

LEAGUE MVPS

Ash Hillin	p,	1937
Al Rosen	3b,	1947
Herb Conyers	1b,	1949
Joe Frazier		1953
Dave Roberts		1965
Steve Buechele		1985
Juan Gonzalez		1990

PLAYOFF APPEARANCES

1914 Western Association: Won championship, 4 games to 2 over Muskogee

1915 Western Association: Won championship, 4 games to 3 over Muskogee

1928 Western League: Finished 2nd; lost to Tulsa 4 games to 1 in finals

1932 Western League: Finished 2nd; beat Tulsa 2 games to 1 for second half title; lost to Tulsa 4 games to 0 in finals

1935 Texas League: Won championship; beat Tulsa 3 games to 1 in semifinals and Beaumont 4 games to 1 in finals

1936 Texas League: Lost 3 games to 1 to Dallas in semifinals

1937 Texas League: Finished 2nd; beat San Antonio 3 games to 2 in semifinals; lost 4 games to 2 to Fort Worth in finals
1938 Texas League: Lost 3 games to 0 to San Antonio in semifinals
1940 Texas League: Lost to Houston 3 games to 1 in semifinals
1949 Texas League: Lost to Tulsa 4 games to 2 in semifinals
1952 Texas League: Finished 2nd; beat Dallas 4 games to 2 in semifinals; lost to Shreveport 4 games to 1 in finals
1953 Texas League: Lost to Dallas 4 games to 3 in semifinals
1954 Texas League: Lost to Houston 4 games to 1 in semifinals
1963 Pacific Coast League: Won championship; beat Spokane 4 games to 3
1965 Pacific Coast League: Won championship; beat Portland 4 games to 1
1979 American Association: Finished second; lost to Evansville 4 games to 2 in finals
1983 American Association: Lost to Louisville 3 games to 2 in semifinals
1985 American Association: Finished second; lost to Louisville 4 games to 1
1992 American Association: Won championship; beat Buffalo 4 games to 0
1996 American Association: Won championship; beat Omaha 3 games to 1 in semifinals and Indianapolis 3 games to 1 in finals
1999 Pacific Coast League: Won American Conference; lost to Vancouver 3 games to 1 in championship
2002 Pacific Coast League: Won Eastern Division of American Conference; lost to Salt Lake City 3 games to 0 in conference championship

LEAGUE CHAMPIONSHIPS

1914 Western Association
1915 Western Association
1923 Western League (no playoffs)
1935 Texas League
1963 Pacific Coast League
1965 Pacific Coast League
1992 American Association
1996 American Association

BOB HERSOM'S ALL-TIME 89ER TEAM

FIRST BASE: Lee Stevens nearly won the American Association Triple Crown in 1996.

SECOND BASE: Jim Morrison hit 53 home runs over four 89er seasons (1976-1979), had 231 RBIs, and hit .289, .294, .265, and .320.

SHORTSTOP: Julio Franco stole 33 bases, hit .300, and slugged 21 homers in 1982.

THIRD BASE: Dean Palmer is the greatest home run hitter, by frequency, in Oklahoma City minor league history. He hit 22 round-trippers in 60 games in 1991.

OUTFIELD: Dave Roberts was the first great 89er player. From 1962 to 1965, he hit .309 with 74 homers and 326 RBIs.

OUTFIELD: Juan Gonzalez led the American Association in home runs and RBI's in 1990.

OUTFIELD: Dan Walton is the only Oklahoma City player ever named Minor League Player of the Year by *The Sporting News*.

CATCHER: Keith Moreland was an All-Star catcher in 1978 and 1979.

DESIGNATED HITTER: Steve Balboni was the American Association's All-Star DH in 1992 and 1993.

STARTING PITCHER: Howie Reed still holds the season record for most wins (19), a feat he accomplished in 1967 when he led the PCL in wins, games started, and innings pitched. In 1968, he won 15 games and pitched a seven-inning no-hitter.

RELIEVER: Matt Whiteside was the difference in the 89ers 1992 pennant drive. He made good on all eight save opportunities down the stretch.

MANAGER: Grady Hatton is the only Oklahoma City manager to win two pennants, 1963 and 1965.
COACH: Mike Berger played or coached for the 89ers for six seasons from 1989 to 1994 and was one of the most popular characters in 89er history.
TRAINER: Greg Harrel

BOB HERSOM'S ALL-TIME REDHAWK TEAM

FIRST BASE: Andy Barkett, maybe the most popular player in RedHawks history.
SECOND BASE: Scott Sheldon, the RedHawks' only two-time PCL All-Star.
SHORTSTOP: Kelly Dransfeldt, starting shortshop for four years, 1999–2002.
THIRD BASE: Tom Quinlan, former hockey star, drove in 97 runs in 1998.
LEFT FIELD: Pedro Valdes, best hitter in Hawk history, .327 and .332 in 1999 and 2000.
CENTER FIELD: Warren Newson, hit .307 with 21 homers and 98 RBIs in 1998.
RIGHT FIELD: Ruben Sierra, ex-89er came back from Korea to hit .326 in 2000.
CATCHER: Mike Hubbard, easily the best catcher in RedHawks history.
DESIGNATED HITTER: Travis Hafner, .342 average in 2002 is third best in Oklahoma City history.
STARTING PITCHER: R.A Dickey, Mr. Dependable, as starter and reliever for part of five seasons.
OTHER HONORABLE MENTIONS—Terry Clark, Doug Davis, Ryan Glynn, and Matt Perisho.
RELIEVER: Joaquin Benoit, 17–9 over the 2001-2002 seasons.
OTHER HONORABLE MENTIONS—Allen McDill, Aaron Myette, Brian Sikorski, and Chuck Smith.
RESERVES: Bret Barberie, Chris Demetral, Ryan Ludwick, Les Norman, Marc Sagmoen, and C.B.J Waszgis.
MANAGER: Bobby Jones has managed the 89ers for two years and RedHawks for two years. Only Greg Biagini has been AAA manager in Oklahoma City longer.
COACH: Bruce Crabbe, with RedHawks for five seasons.

The press box at the The Brick is named for the late Volney Meece, longtime sportswriter for *The Daily Oklahoman*. In this photograph, Meece (right) watches an 89er game with fellow sportswriter Bob Hersom in the old press box at All Sports Stadium in 1991. (Oklahoma RedHawks.)